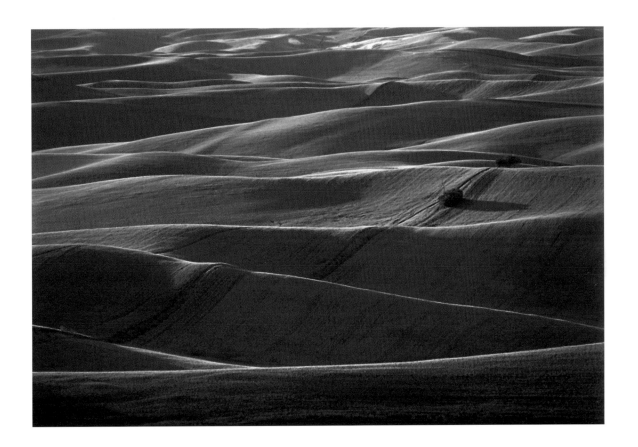

...a region of
dune-like, rolling hills
extending across southeastern Washington
and a portion of northern Idaho...

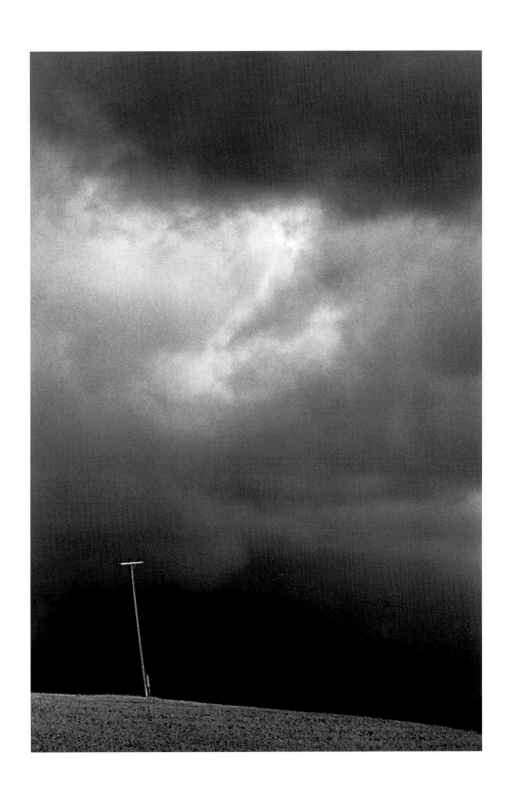

…a remote and lonely place…

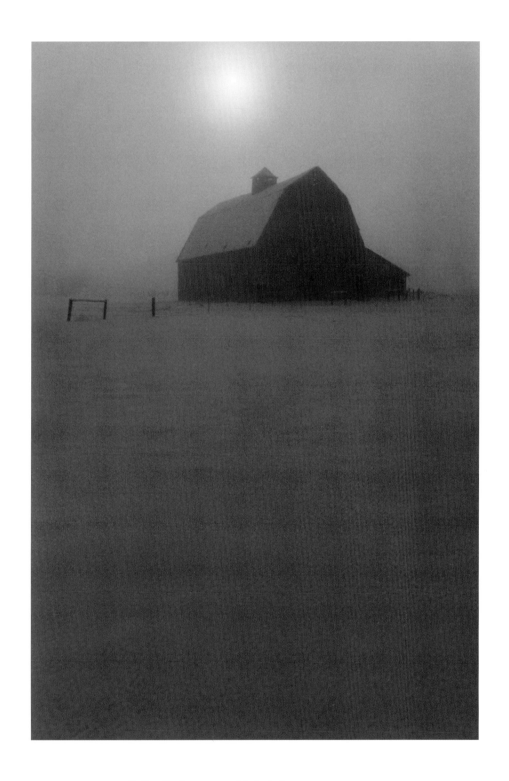

*...full of a beauty which is in turn
haunting, mysterious, noble, austere, and tender.*

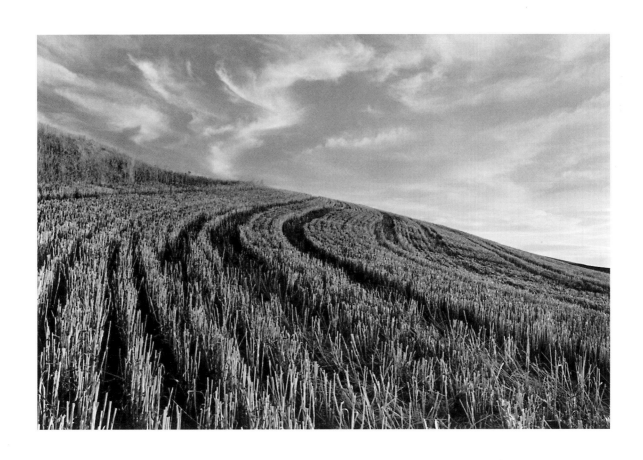

*To the west of its 2,000 square miles
are the plains of central Washington;
to the north and east, mountains;
and to the south, the Snake River.*

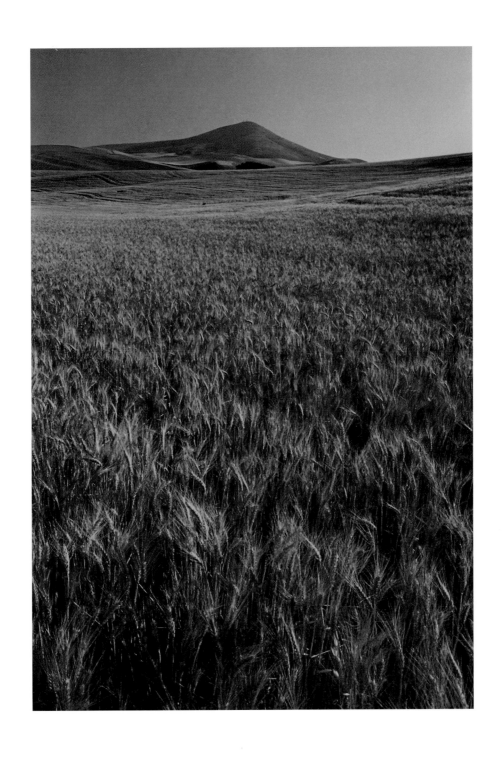

Within these bounds,
and stretching away in all directions,
is the wheat.

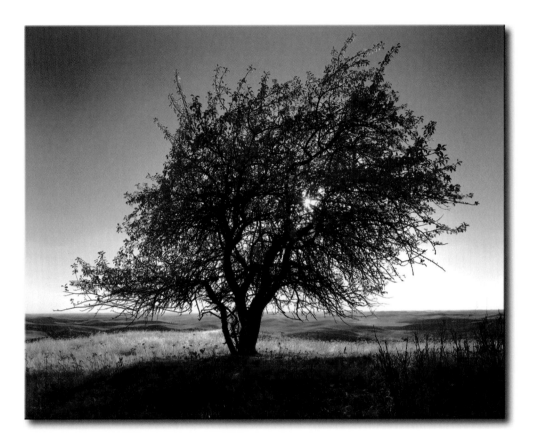

Palouse Country

GEORGE BEDIRIAN

Washington State University Press
Pullman, Washington

Washington State University Press
PO Box 645910
Pullman, Washington 99164-5910
Phone: 800-354-7360
Fax: 509-335-8568
E-mail: wsupress@wsu.edu
Web site: www.wsu.edu/wsupress

Library of Congress Cataloging-in-Publication Data

Bedirian, George, 1939–
 Palouse country / George Bedirian ; afterword by Terry Lawhead.
 p. cm.
 Originally published: Colfax, Wash. : Whitman County Historical Society, 1987.
 ISBN 0-87422-254-0 (pbk. : alk. paper)
 1. Palouse River Valley (Idaho and Wash.)—Pictorial works. I. Title.

F752.P25B43 2002
979.7'39—dc21 2002008759

Cover and title page photo: While the heights of Whitman County's Steptoe Butte provide unparalleled views of the Palouse Country landscape, the butte offers riches of its own to those who take the time to find them. Such is the case with this apple tree, one of many scattered across the butte's lower slopes. My discovery of the tree one autumn afternoon was part of a convergence in which the tree, the season, the weather, and the hour conspired to produce a moment of ineffable beauty. As a witness to this convergence, my role was to make a record of the event—and the image you have before you is, of course, the result. I value this photograph for two reasons. First, it stands in my mind as the perfect representation of "Palouseness": that combination of light, air, and landscape that can only be found in the Palouse. Second, it speaks to me of the efficacy of "being there"; of keeping our wits warm, to paraphrase the English poet Gerard Manley Hopkins, to the things that are; of truly seeing the world around us. That, among other things, is what this book is about.

—*George Bedirian*

CONTENTS

To my parents,
Levon H. and Zarouhy Bedirian

INTRODUCTION

The last quarter of the 19th century was a time of rapid growth in the Palouse. Pioneer farmers were transforming the virgin grasslands into wheatfields. On the Snake River, steamboats were doing a thriving business carrying grain to market and bringing large numbers of people into the Palouse, many of whom settled along the river, where the long growing season and the ready accessibility of shipping made fruit growing profitable.

The upland communities were also thriving. The most substantial buildings of almost every Palouse Country town were constructed in the years that spanned the turn of the century. The old schoolhouse in Farmington (p. 5), the St. Elmo Hotel (p. 21), and the Powers Block in Palouse, the Bank of Rosalia (p. 18), the First Baptist Church in Oakesdale (p. 8), and the Roman Catholic churches in Colton (p. 29), Uniontown, and Sprague (p. 26)—all were built between 1889 and 1902.

By 1900 a system of railroads connected the towns to one another and brought them prosperity—or at least the promise of it. The author of an 1893 promotional booklet on Washington's Whitman County used the coming of the railroads to clinch his argument for the desirability of settling in Uniontown: "…lots in Uniontown which can be bought at low prices on easy terms now, will soon be selling for double the present prices and for cash. The Great Northern railroad is building toward Uniontown and expects to have its line completed to that town by January 1st, 1894, and then the boom will begin. You will never have such a grand opportunity to 'get in on the ground floor' as at present, and if you let the year 1893 go by without investing in Uniontown you will miss a golden opportunity but will have no one but yourself to blame."

Even before this was written, the Spokane and Palouse Railroad, a branch of the Northern Pacific, was carrying passengers south to Uniontown. Because travelers had to disembark at this point and continue their journey by stagecoach, the town, already a key storage and shipping center for grain, acquired additional importance as a terminal and transfer point. By the opening of the 20th century, it boasted several hotels, a brewery, at least two schools, a major church building, an opera house, and more. As a growing community, and as the focal point of a developing locale, its continued prosperity seemed assured.

Though blatantly promotional in its intention, the passage quoted above reflected a genuine optimism about the future that pervaded the entire region. J. Arthur Hanford, writing in *Oakesdale Memories,* recalled that his father, E.H. Hanford, "thought in the early days that Oakesdale had a good chance to become a sizeable city, and went so far as to plat an addition to the Town of Oakesdale in our field." Hanford had good reason to be optimistic. Oakesdale at the century's turn was a thriving community of some 2,000 souls. Eight churches served the spiritual needs of the townspeople, and an equal number of saloons quenched their thirst. With a full complement of businesses besides—including "the pride of the Palouse Country," the Oakesdale Opera House—and with three railroads linking the town to the outside world, it was little wonder that E.H. Hanford saw house lots sprouting in his field.

Though it equaled Oakesdale in population, the town of Palouse, or Palouse City, as it was then called, looked forward to an even brighter future. Three hotels, two banks, and one of the largest lumber mills west of the Rockies lent weight and importance to the town, as did a substantial population of dentists, pharmacists, and lawyers. Tailors and dressmakers clothed its people, a resident photographer recorded their faces on film, the Palouse General Hospital cared for them when they were ill, and an undertaker buried them when they died.

The Powers Opera House attracted medicine shows and traveling theater companies from the East and provided a forum for such luminaries as Carrie Nation and Victor McLaglan. Even Theodore Roosevelt included Palouse on his western itinerary. Clearly, it was a town to be watched.

To one degree or another, the same youthful vigor that animated Uniontown, Oakesdale, and Palouse characterized a score of other Palouse Country towns. Each provided important commercial, social, and cultural services to the people of its district, and each was a vital part of a balanced order of things—a decentralized, small-grained order that worked for the benefit of both town and country and that, for all anyone knew, was destined to go on forever.

But a chain of events was already in motion that was to undermine the stability of that order and change it irrevocably. It began with the coming of the automobile and the transition from horse-drawn to self-propelled farm machines. Together these two phenomena were to transform the face of the countryside, drain the Palouse of much of its population, and cut short the development of the towns so completely as to spell the demise of some and a diminished existence for many others.

The automobile created a need for improved roads and highways and thus brought an end to the relative isolation of the towns. This in turn meant that people no longer had to depend exclusively, or even primarily, on the towns for goods and services. Consequently, one local business after another shriveled and died. Tradesmen and merchants closed up shop and moved on, followed by the people they had once employed. When the young, seeing no future for themselves in their own communities, chose to try their luck elsewhere rather than to stay, the downward spiral became irreversible.

Not every town suffered this kind of decline. Because they hosted the land-grant colleges of their respective states, Pullman, Washington, and Moscow, Idaho, continued to develop. Today they are well-established as the commercial, educa-

tional, and cultural nexus of the Palouse. Colfax, the seat of Whitman County, enjoys a corresponding preeminence as an agricultural service center and the locus of a large number of county agencies and government offices. And the towns of Endicott, St. John, Garfield, Rosalia, Tekoa, and Fairfield have retained their vitality as farming communities.

For the rest, however, the wave of change that engulfed the Palouse was catastrophic. Some, like Pampa and Wilcox, were swept away so completely that nothing remains of them but their names. Some, like Diamond, Ewan, Thornton, Elberton, Winona, Dusty, Pine City, Hooper, Johnson, and Lancaster, function more as rural communities than as towns. And some—including Uniontown, Oakesdale, and Palouse, as well as Farmington, La Crosse, Colton, and Albion—live on, but at a slower tempo than before.

The changes in the countryside that attended the transition from horse-powered to motorized farming were equally disruptive. Before the advent of the new machines, farms had been forced to remain relatively small—a few hundred acres at most. Plowed fields were interspersed with horse pastures, and in many places commercial fruit orchards flourished on the hills. Because farming was labor-intensive, the countryside provided seasonal employment for large numbers of people— and regular employment for teachers, who educated the children of farmers and farm hands in the many schoolhouses scattered throughout the Palouse.

The new machines made it possible to raise a larger crop with less work, and they increased the productivity of the Palouse many times over. To the farmers who used them successfully, they brought prosperity. But to others they brought unemployment and displacement. Because they could be used profitably only on larger acreages than were available, they precipitated a cycle of buying and selling, the result of which was to consolidate the many small farms into larger ones. And because they required fewer people to operate them than the horse-drawn rigs of old, those who

had previously depended on finding work on the farms watched their jobs evaporate before their eyes and joined the exodus from the countryside. As the rural population thinned, so also did attendance at the country schools. Teachers found themselves without work, local school districts were absorbed by the towns, and the schoolhouses, abandoned now, were torn down to make way for the expanding fields.

These alterations in the social fabric of the Palouse were accompanied by corresponding changes in the physical landscape. Because the use of horses was on the wane, fewer pastures were needed, and they were plowed over. And since motorized farming firmly established the supremacy of wheat culture in the Palouse, the orchards that once held promise became irrelevant as cash crops and were cut down. The farmsteads that were abandoned in the process of consolidation have virtually disappeared. All that remains of them today are a few deserted farmhouses and barns that stand like islands in the midst of the surrounding fields.

The barns of the Palouse are, in fact, the most numerous relics of the premotorized era and the most interesting and conspicuous features of the rural landscape. Displaying a rich profusion of styles, these structures are superb examples of the vernacular architecture of the region, and they stand as organic expressions of the life from which they sprang. But because they no longer serve their original purposes of sheltering animals and storing the hay that fed them, many remain vacant and unused. And although some have been converted to other uses, as a class of buildings they are slowly disappearing from the Palouse.

Of the 30 barns depicted in this book, for example, 11 no longer exist. These include the Elsie Blane barn (p. 84), the Richard McCroskey barn (p. 83), one of the two Robert Young barns on page 69, the Eugene Brannon barn (pp. vii and 74), the Richard Hall barn (p. 64), the Steever barn (p. 66), the Thelma Gray barn (p. 75), the Elmer Blackman barn (p. 71), the Duveen Kosola barn (p. 65), the Tom Busch barn (p. 73), and the

Earl Mohr barn (p. 78). The loss of the Hall barn, famous for its round design, was particularly severe, since it was only one of three round barns in the Palouse. Structural weaknesses, coupled with the lack of funds necessary for its rehabilitation, made it necessary to destroy the barn. Of the two round barns that remain, only one displays the arched dormer treatment shown on page 64. The other round barn, the Leonard barn near Pullman (p. 79), stands as a notable exception to the fate of many other Palouse Country barns. Listed on the National Registry of Historic Places, it was restored in 2001 and publicly reopened in August of that year.

Hundreds of other barns across the Palouse suffer the ravages of age and neglect. As of this writing, the main portion of the Leonard Beavert barn, part of whose roof can be seen in the photo on page 85, is in a state of near-total collapse. Most grievously, the entire central portion of the roof of the Sharon Hanford barn (page 63), the finest of all the barns in this book, has been torn away, leaving a gaping hole where the cupola formerly stood, exposing the interior to the weather, and hastening its demise.

It could be argued that, though regrettable, the disappearance of the barns of the Palouse is simply a longer-term adjustment to agricultural progress than the other changes described above, and that their eventual loss is part of the price the Palouse must pay for becoming one of the most productive grain-growing regions in the world. A high price for progress—but not the highest. Perhaps the severest problem which that productivity has visited on the Palouse is the erosion of its soil.

Though soil erosion has always been associated with farming in the Palouse, its severity increased dramatically when tractors replaced horses and more land was placed under the plow. Between 1939 and 1977 the Palouse lost an average of 14 tons of soil per year from every cropland acre—an estimated 40 percent of its soil base. In 1979, attempting to stem that rate of loss, the Washington State Department of Ecology recommended a number of erosion control measures, which many

farmers were quick to adopt. Through no-till seeding, strip cropping, terracing, conservation tillage, and other practices, Palouse Country farmers succeeded in reducing the annual rate of erosion by some 10 percent between 1979 and 1994. According to a 1998 study, *Soil Erosion in the Palouse River Basin: Indications of Improvement,* the Palouse lost an average of 1.4 tons of soil per acre-foot per year between 1993 and 1998—half the annual loss it suffered from 1962 to 1971, and a vast improvement over the average annual loss it endured between 1939 and 1977.

Yet we have only managed to slow the rate of erosion, not to stop it. The fact remains that the soils of the Palouse are inexorably disappearing.

The use of chemical fertilizers, high-yield wheat varieties, improved tillage methods, and better chemical weed sprays has tended to counterbalance this loss and has enabled the Palouse to deliver record or near-record crop yields in recent years. But whether these factors can sustain such productivity in the face of persistent erosion is far from certain. It seems reasonable to assume, rather, that unless a breakthrough occurs in conservation, productivity, or both, the effect of continuing erosion will be a decline in productivity which no amount of technology will be able to offset.

We can only guess what kinds of social, economic, and ecological changes might occur in the wake of such a decline. Conceivably, the Palouse will accommodate itself to the gradual destruction of the fertility upon which its social and economic foundations rest. But it is equally conceivable that the Palouse will become a living embodiment of William Jennings Bryan's dictum: "Burn down your cities and leave your farms, and your cities will spring up again as if by magic; but destroy our farms and the grass will grow in the streets of every city in the country."

Whichever way the pendulum swings for the human community of the Palouse, the essential Palouse—the Palouse of nature's making—will remain. This will hold true, I believe, no matter how many cycles of human change we wreak upon these hills. Our presence in the Palouse is only an episode, after all, in a natural history that predates human memory and that will endure long after we are gone. And though we may strip these hills of the loam that nourished the bunchgrass and wildflowers of the past, the soil that remains will bear other grasses and other flowers. And they will reclaim the Palouse as their own.

It will be as though I carried some
human thing—a metal pail, perhaps—into
a field of meadow grass,
and forgetting why I held it in my hand,
set it down and left the field forever.
Year after year the summer grass grew
tall around the pail,
and the winter grass blew down and died,
leaving the pail exposed and open to the sun.
And when the weather had beaten it to rust,
and my own white bones had crumbled,
it fell away, flake by brittle flake,
into the receiving earth,
and not a sign remained that it had ever been.
Where I had walked, and where the pail had
stood—where men had toiled by day and
lovers had lain by night—
where crops had grown
and footfalls echoed
down the empty streets—
everywhere upon that field,
which stretched away now
into the farthest reaches of the Palouse,
fresh green shoots were sprouting
through the old dead stalks
of last year's growth.
Spring had come again,
and the grass, which had never really died,
was playing out once more
the cycle of its own renewal…
…just as it always had…
…just as it always will…

George Bedirian

PALOUSE COUNTRY

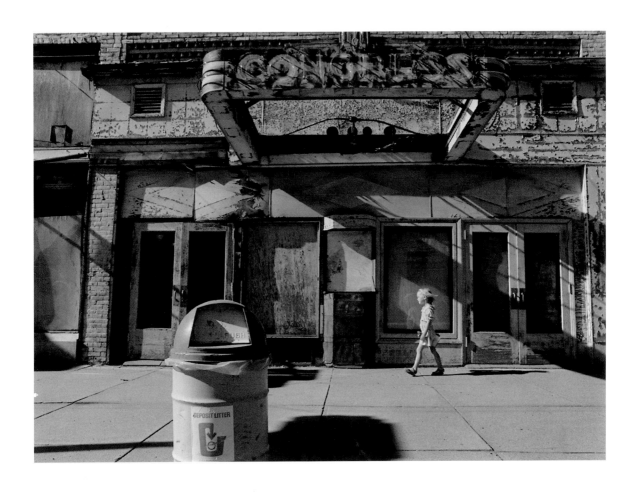

Congress Hotel, Palouse, Washington

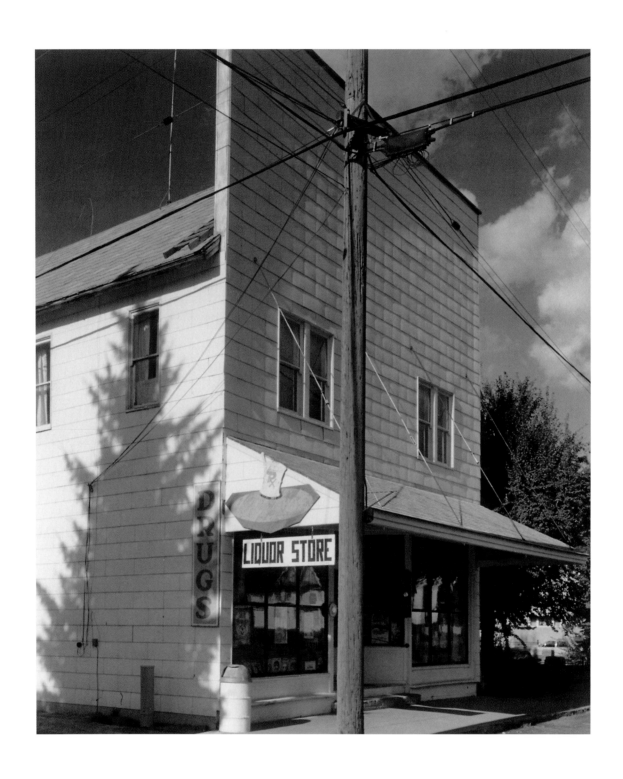

Endicott Drug, Endicott, Washington

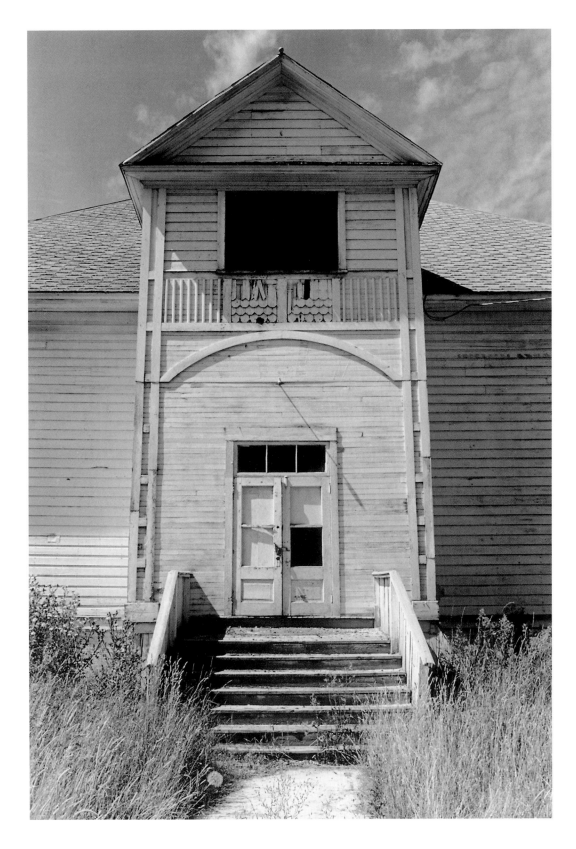

Old Farmington Schoolhouse, Farmington, Washington

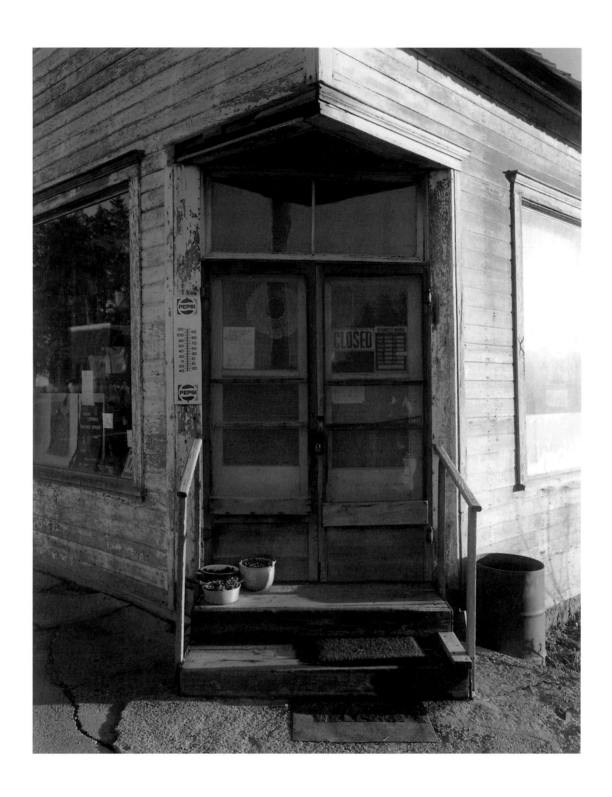

Farmington General Store, Farmington, Washington

6

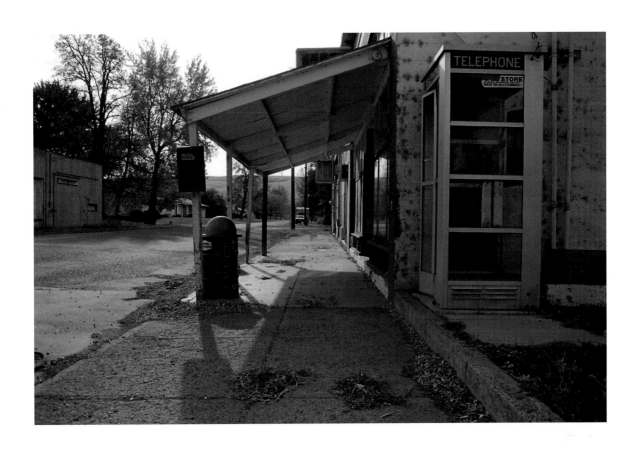

Starbuck, Washington

7

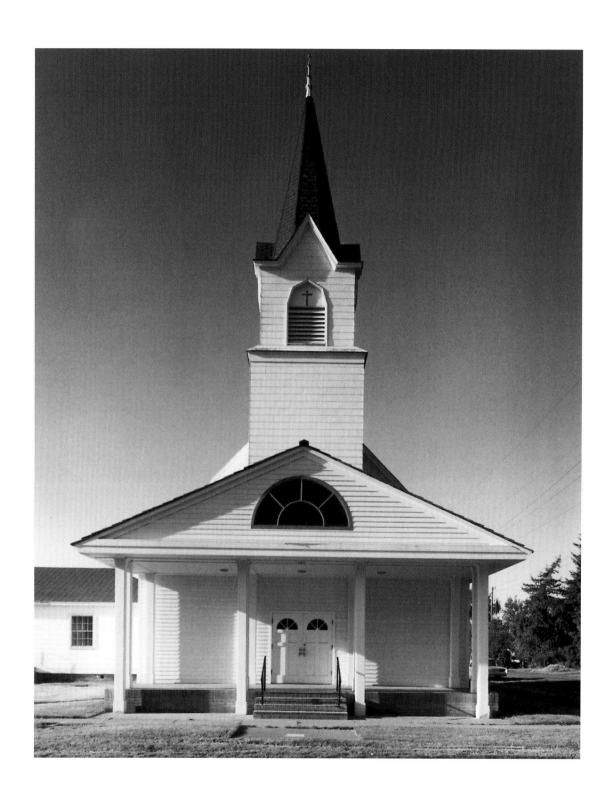

First Baptist Church, Oakesdale, Washington

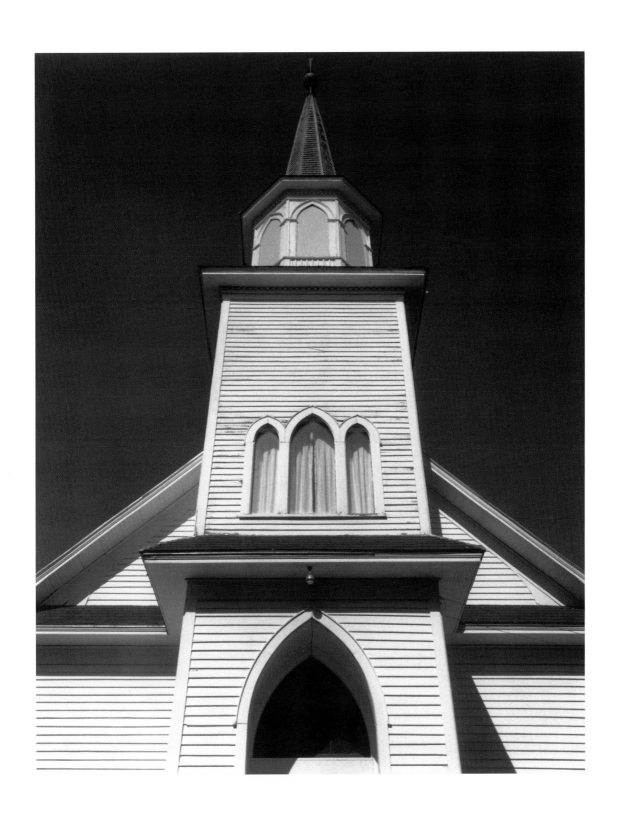

Genesee Valley Lutheran Church, north of Genesee, Idaho

9

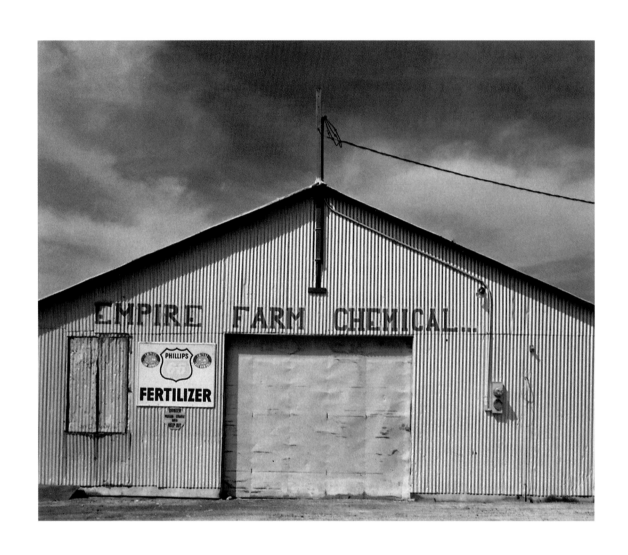

Empire Farm Chemical, Moscow, Idaho

10

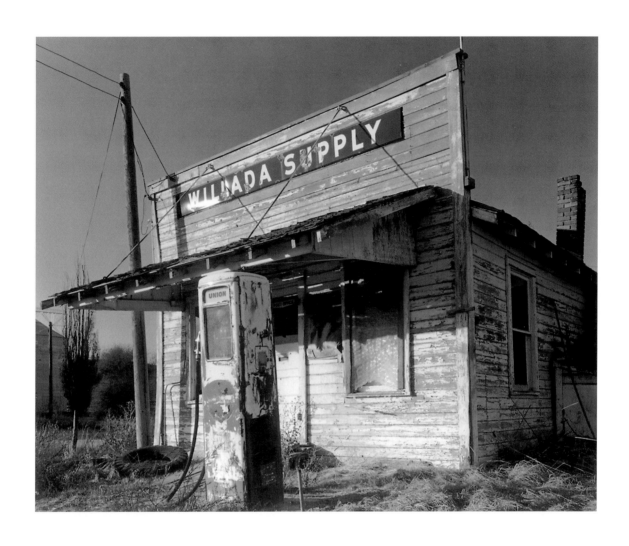

Willada Supply, Lancaster, Washington

11

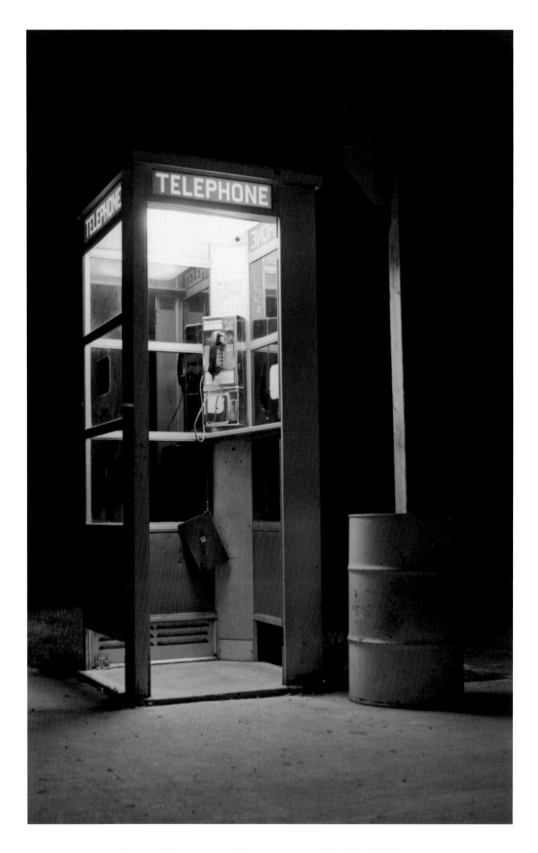

Corner of First Street and Steptoe Avenue, Oakesdale, Washington

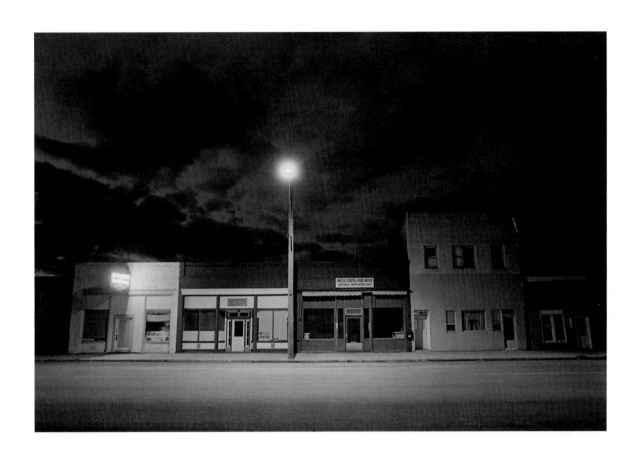

Steptoe Avenue, Oakesdale, Washington

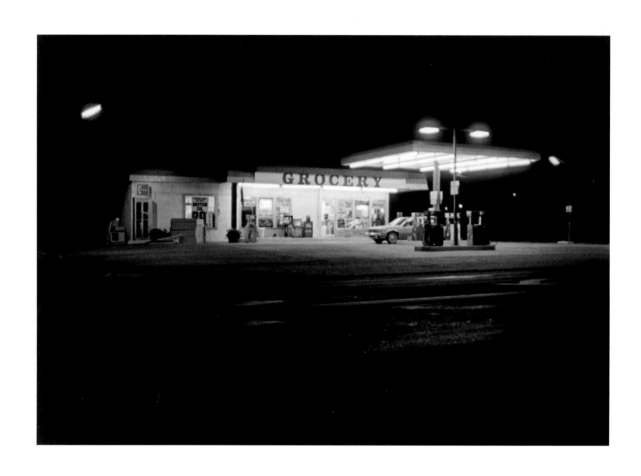

Jackpot Food Mart, Colfax, Washington

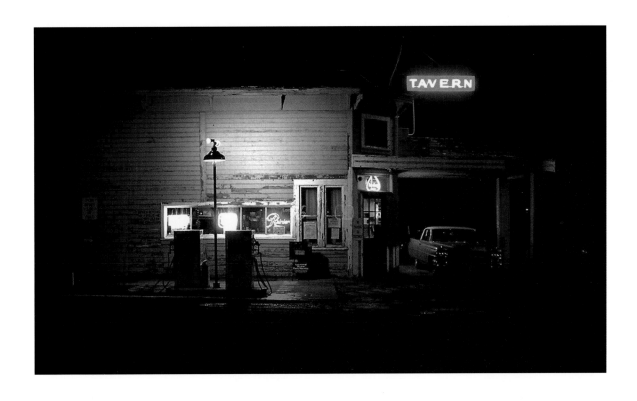

Iron Horse Tavern, Colton, Washington

15

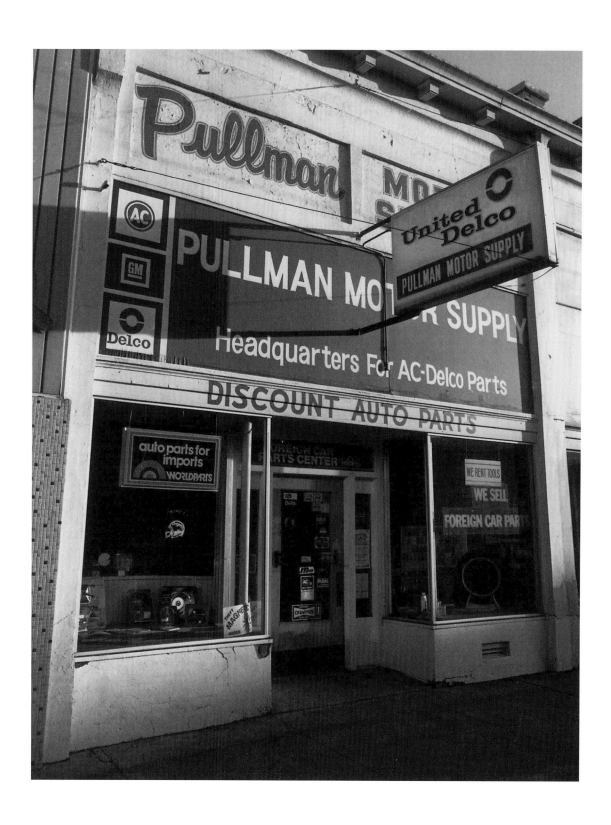

Pullman Motor Supply, Pullman, Washington

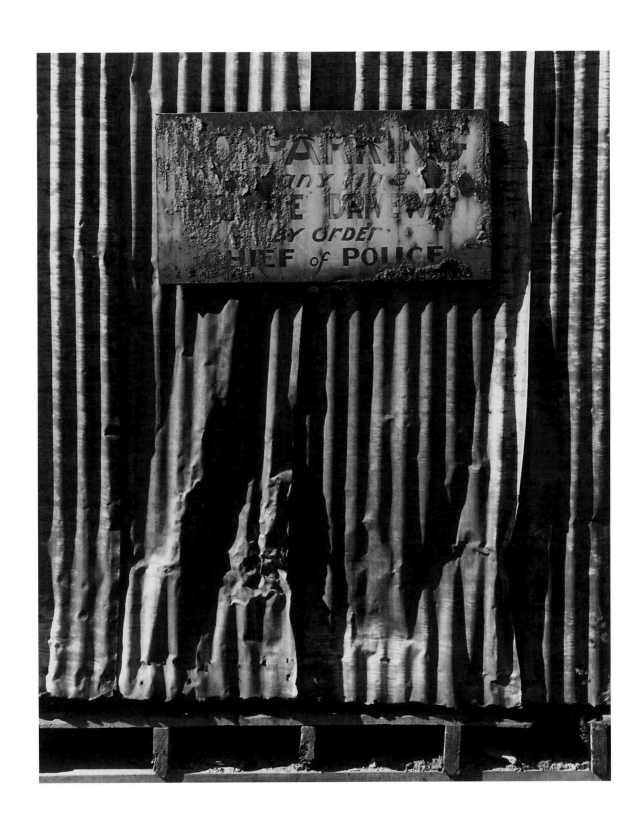

Paradise Street, Pullman, Washington

17

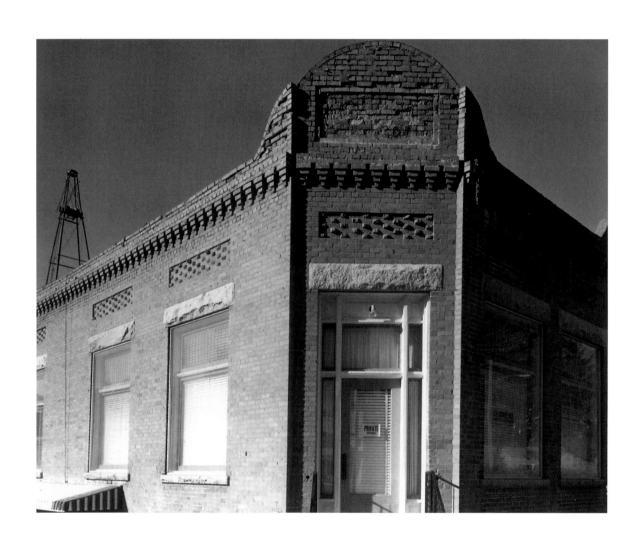

The Old Bank of Rosalia Building, Rosalia, Washington

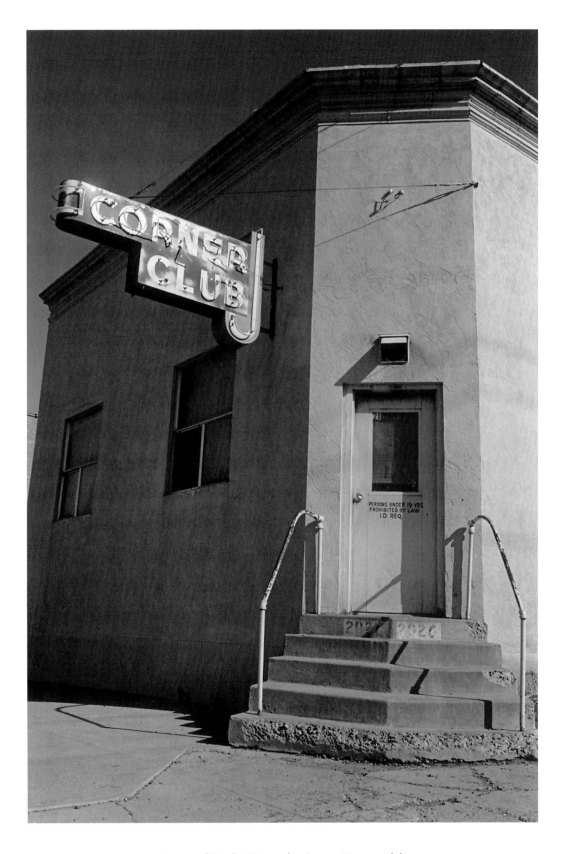

Corner of North Main and A Streets, Moscow, Idaho

19

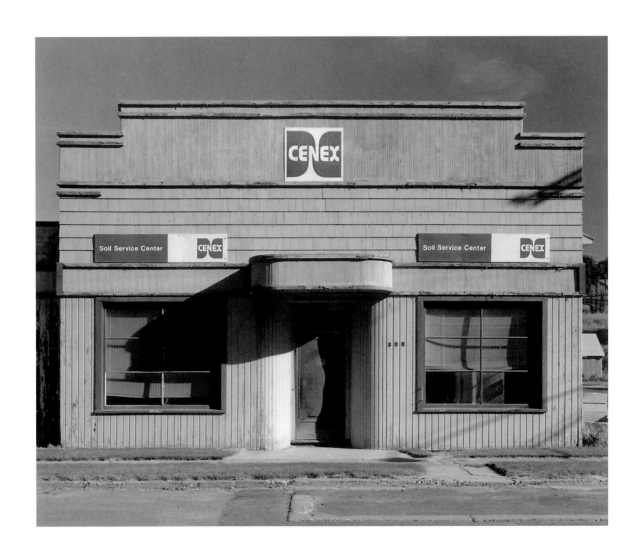

CENEX Soil Service Center, Palouse, Washington

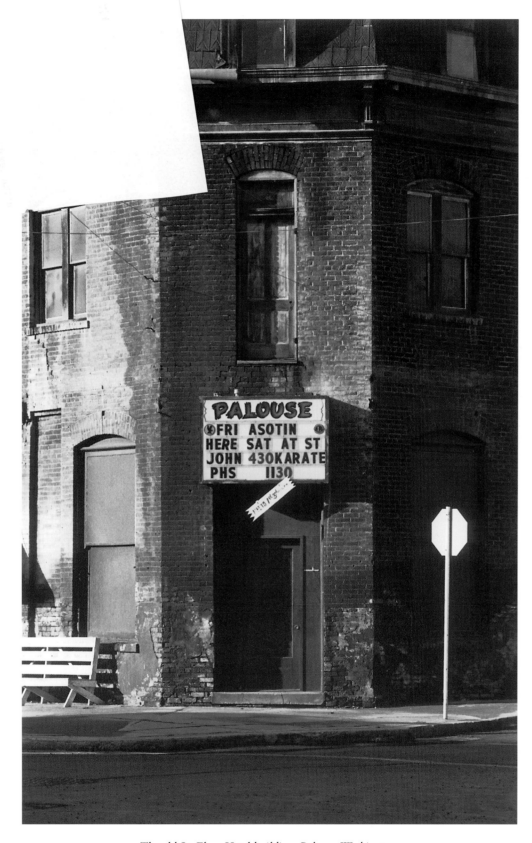

The old St. Elmo Hotel building, Palouse, Washington

21

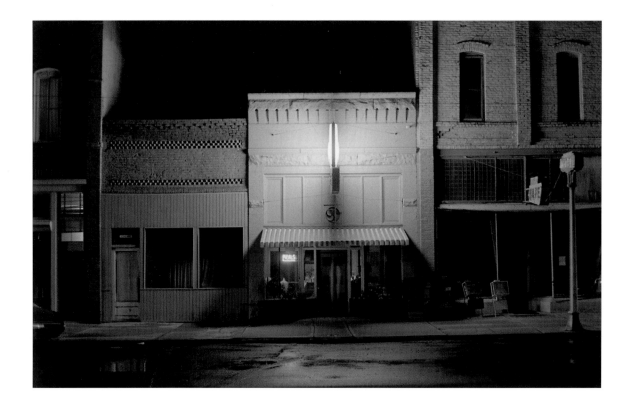

Oasis Cafe, Palouse, Washington

22

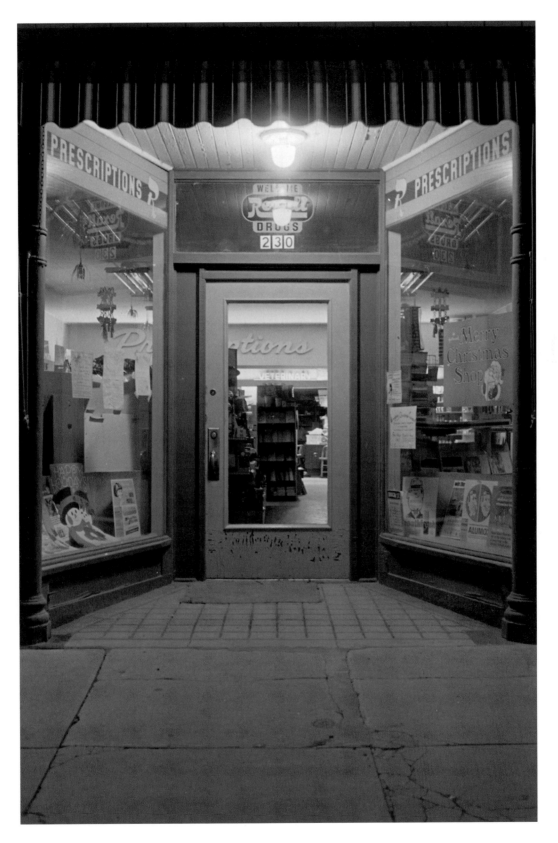

Palouse Pharmacy, Palouse, Washington

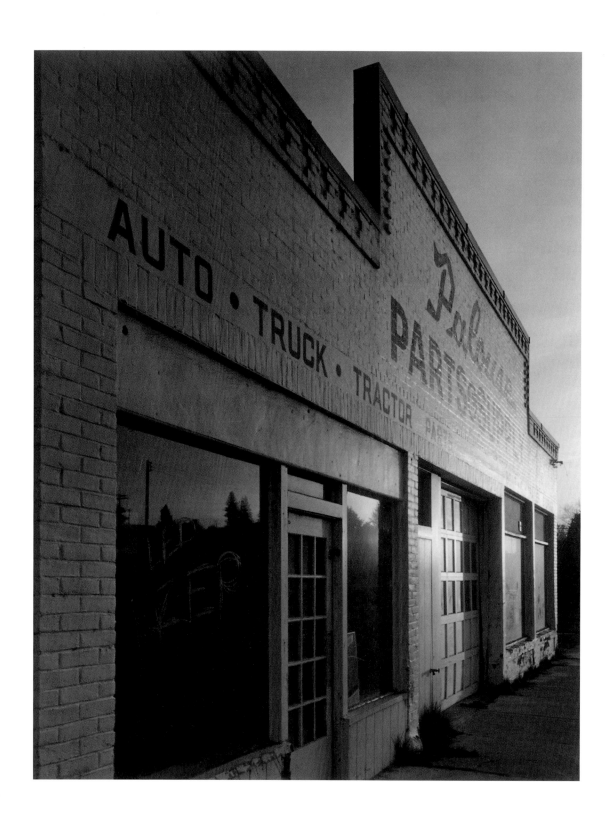

Palouse Parts & Supply, Palouse, Washington

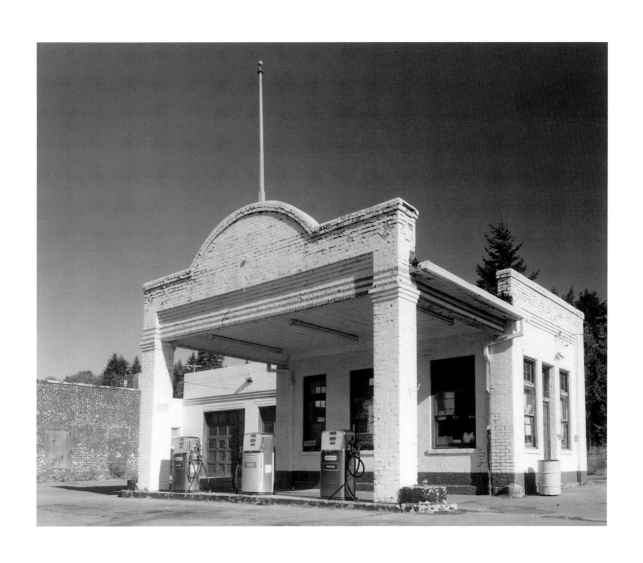

Busch's Conoco Station, Rosalia, Washington

25

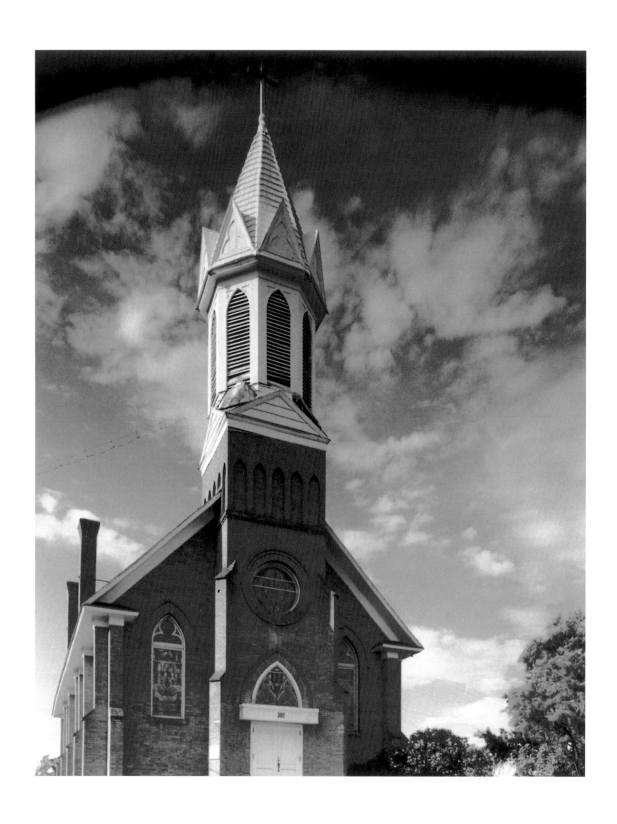

Mary Queen of Heaven Catholic Church, Sprague, Washington

26

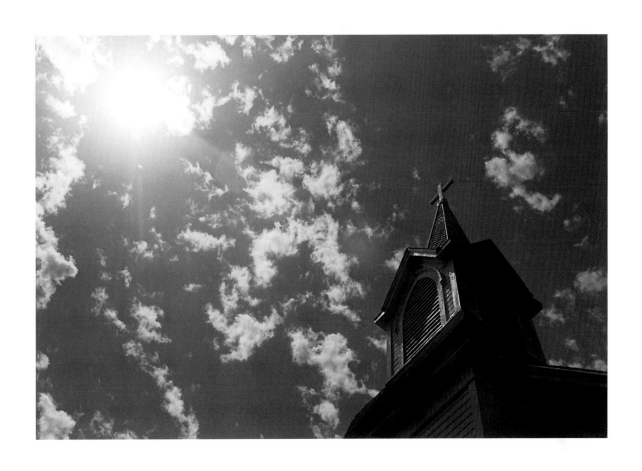

Seventh Day Adventist Church, Rosalia, Washington

27

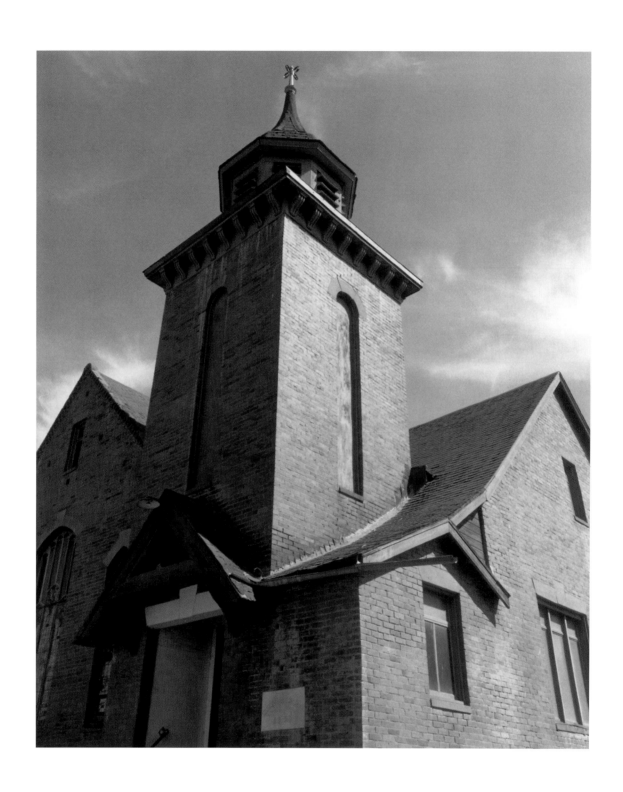

Rosalia Christian Church, Rosalia, Washington

28

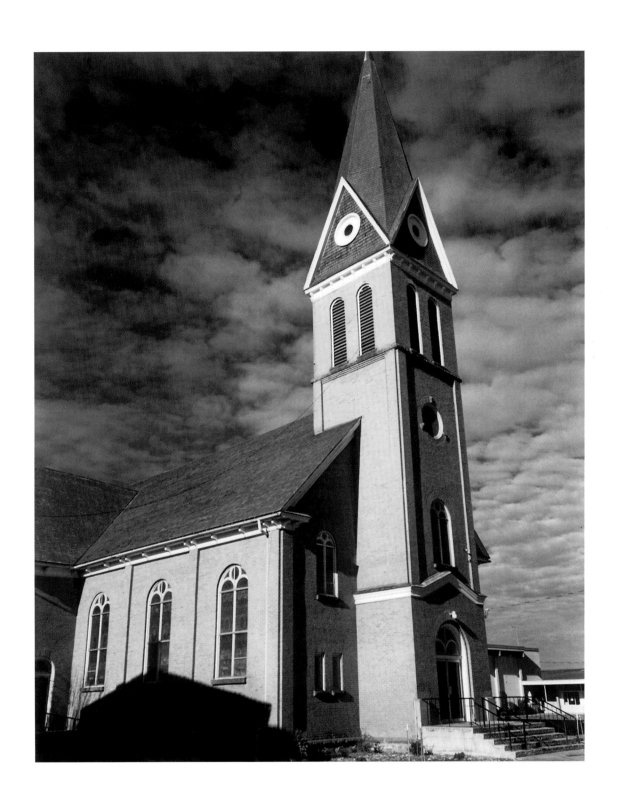

St. Gall's Catholic Church, Colton, Washington

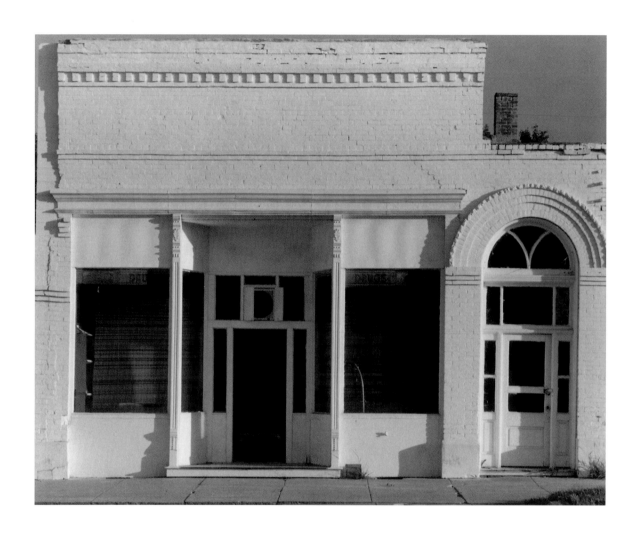

Commercial block, Oakesdale, Washington

30

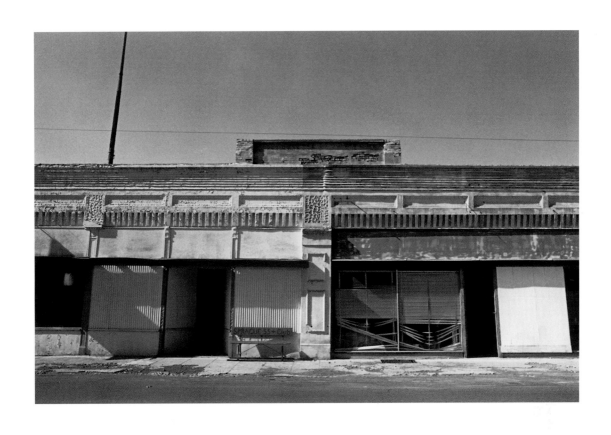

Commercial block, Sprague, Washington

31

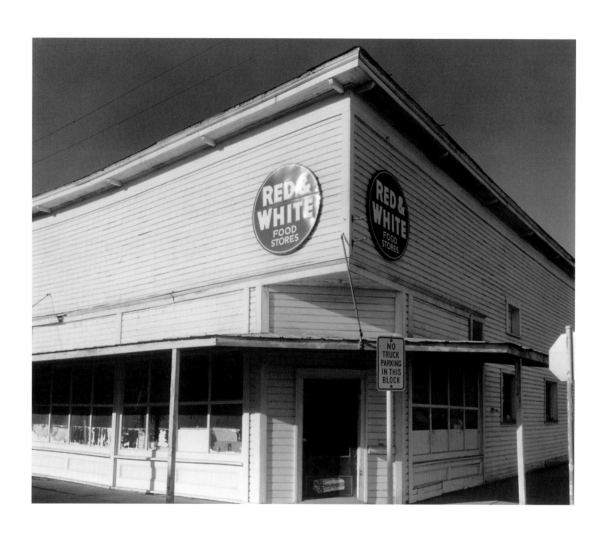

Corner of Park and Front Streets, St. John, Washington

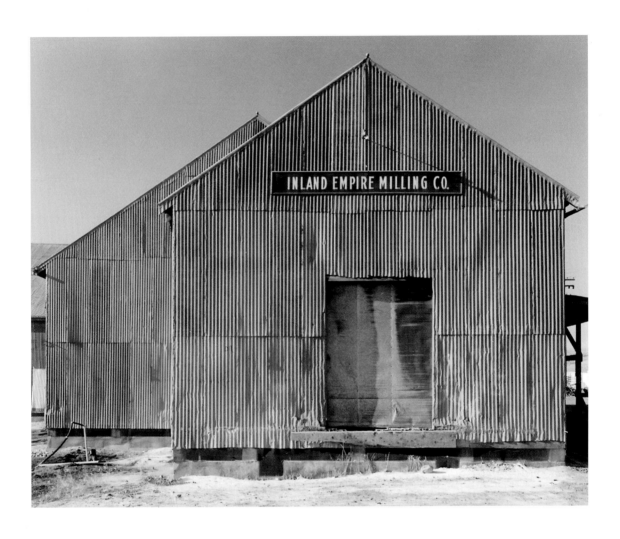

Inland Empire Milling Company, St. John, Washington

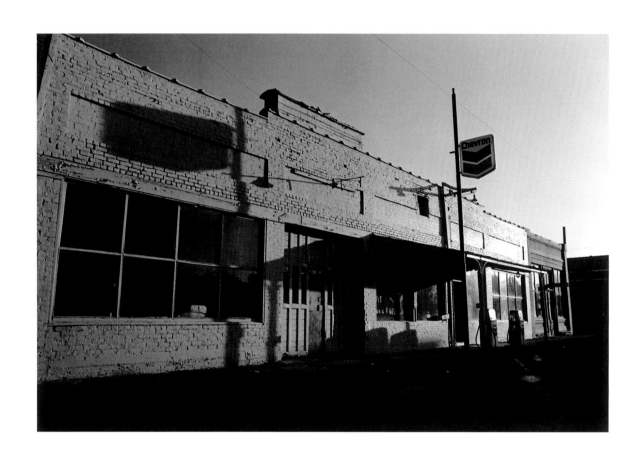

Highway Garage, Sprague, Washington

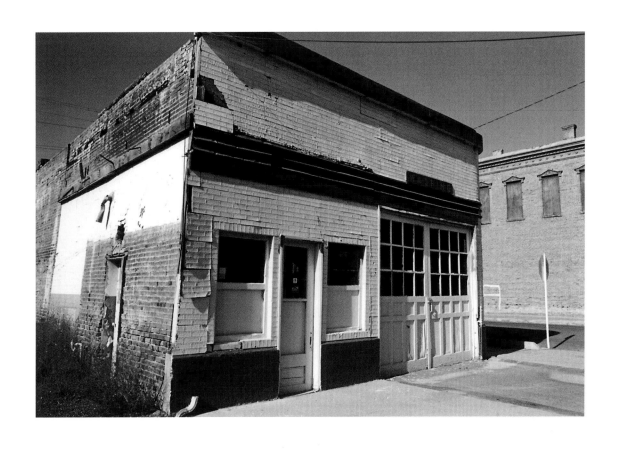

Abandoned car wash, Sprague, Washington

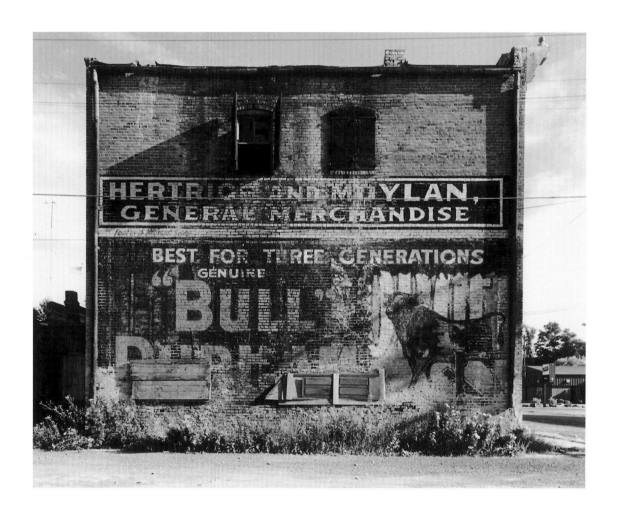

Commercial block, Sprague, Washington

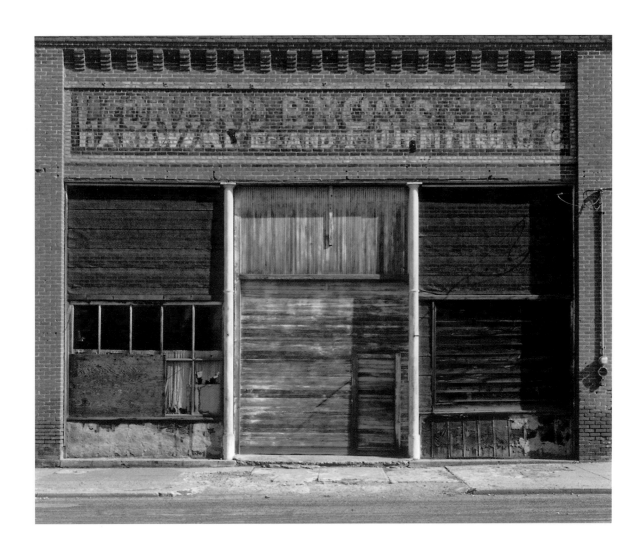

Abandoned commercial block, Uniontown, Washington

37

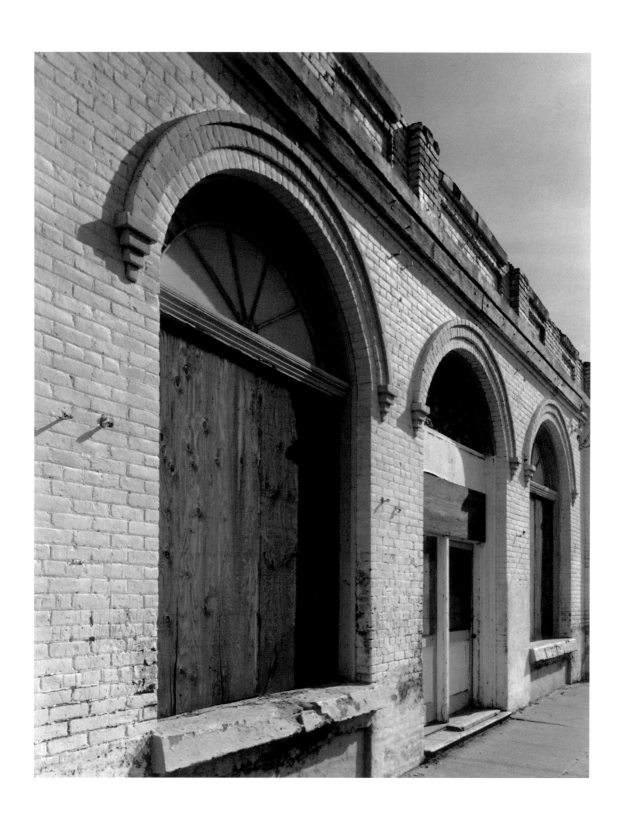

Abandoned commercial block, Uniontown, Washington

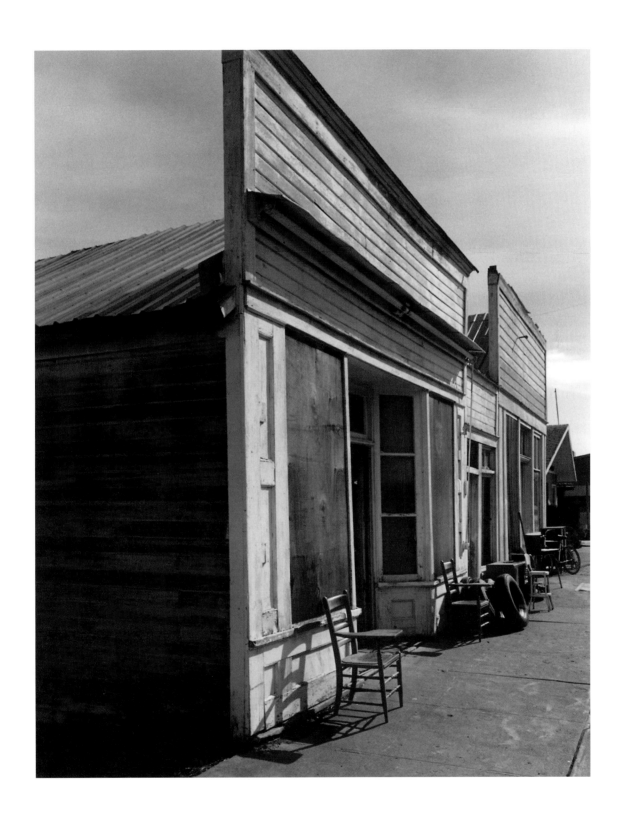

Abandoned frame buildings, Uniontown, Washington

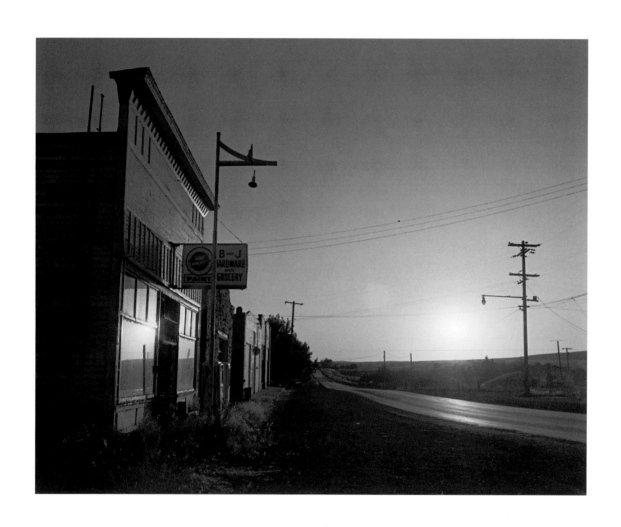

B and J Hardware and Grocery, Winona, Washington

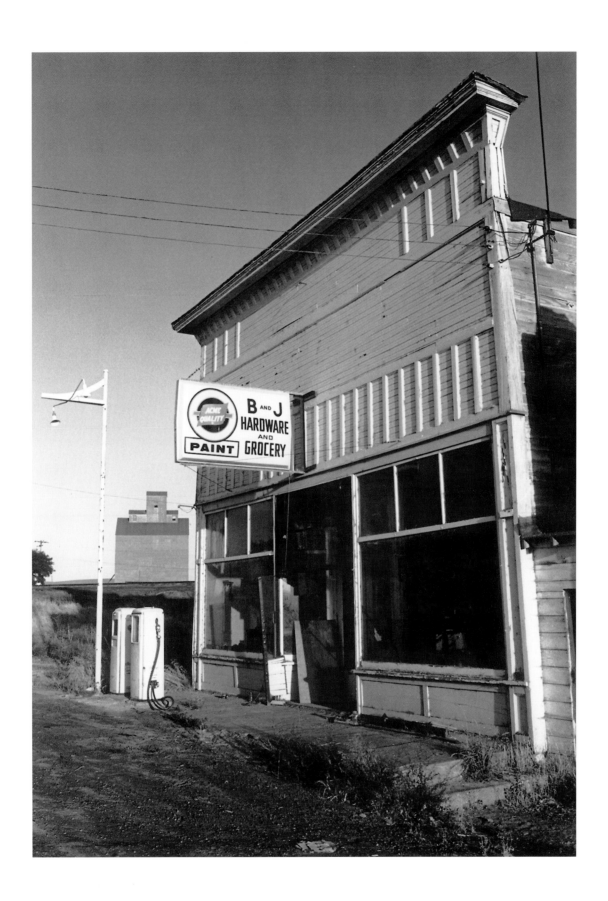

41

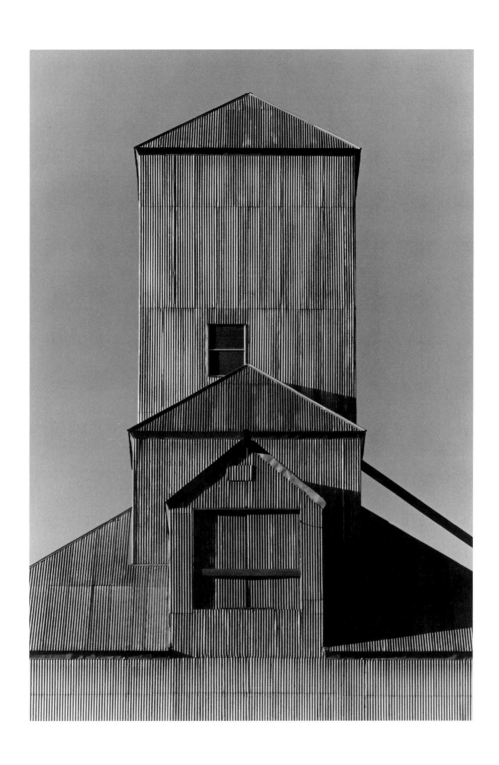

Oakesdale Grain Growers, Inc. elevator, Garfield, Washington

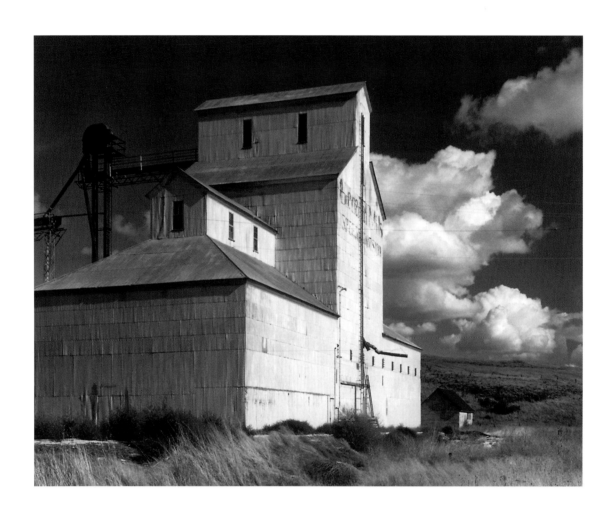

General Mills Sperry Division elevator, Winona, Washington

44

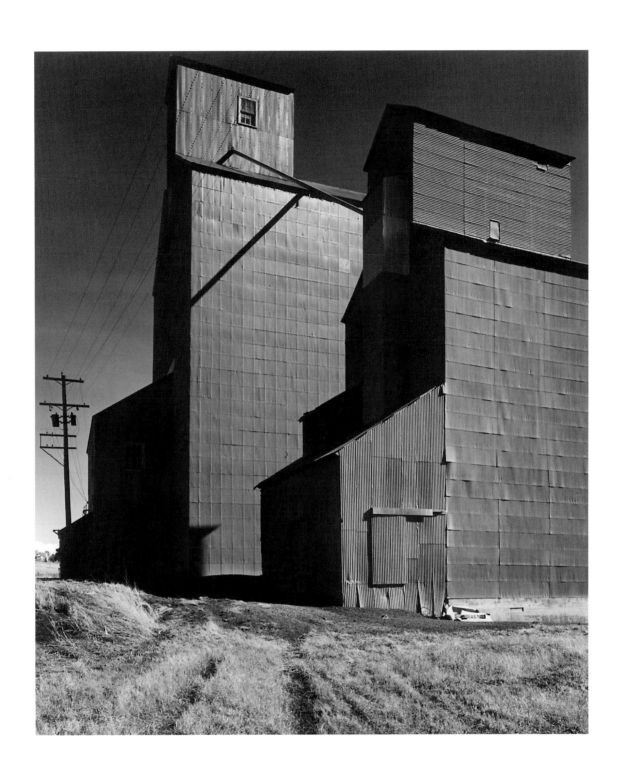

J.M. and Carl Boyd elevator, Whitlow, Washington

45

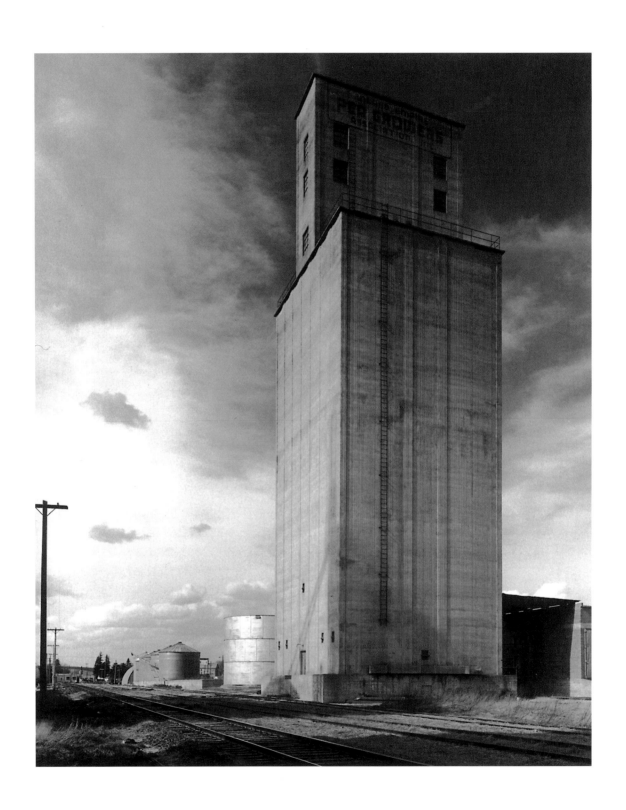

Inland Empire Pea Growers seed plant, Oakesdale, Washington

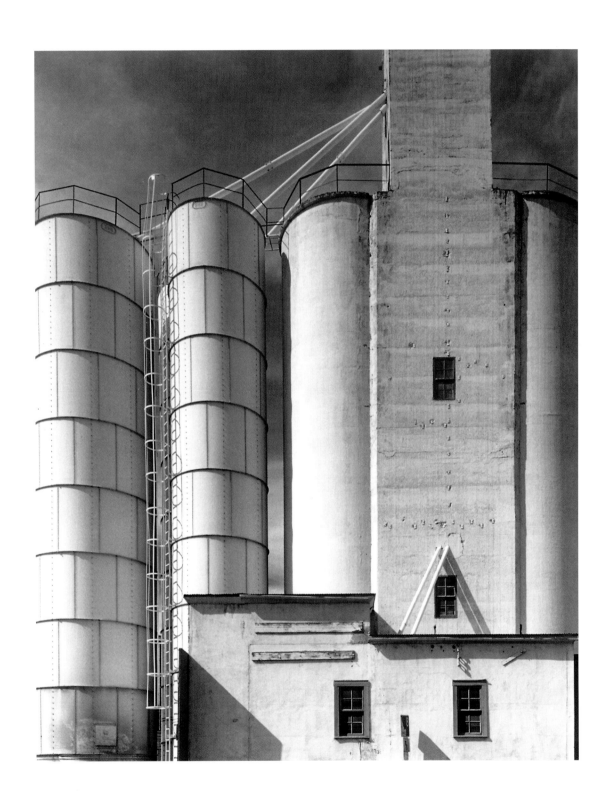

Latah County Grain Growers seed plant, Moscow, Idaho

47

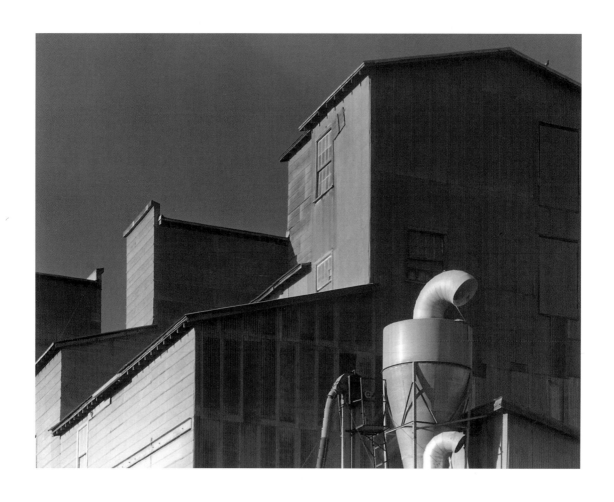

Moscow Idaho Seed Company, Moscow, Idaho

48

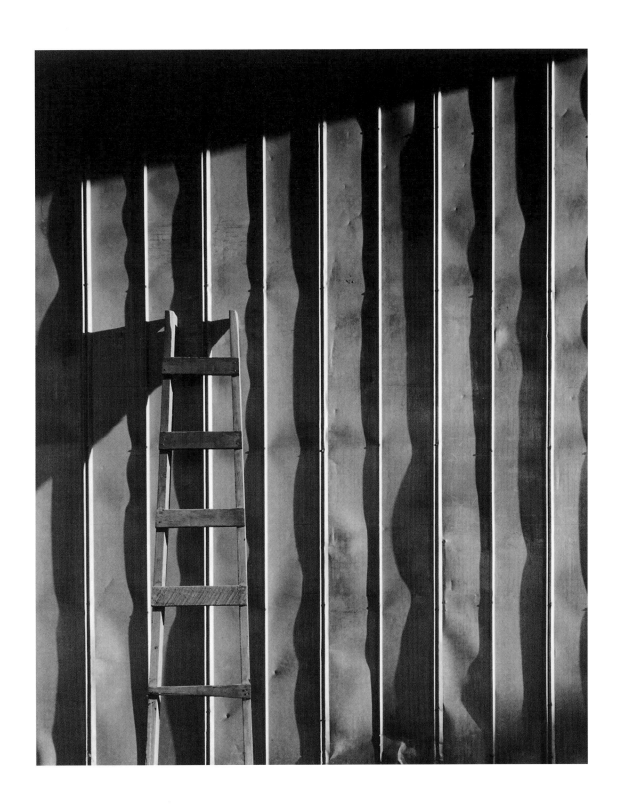

Moscow Idaho Seed Company

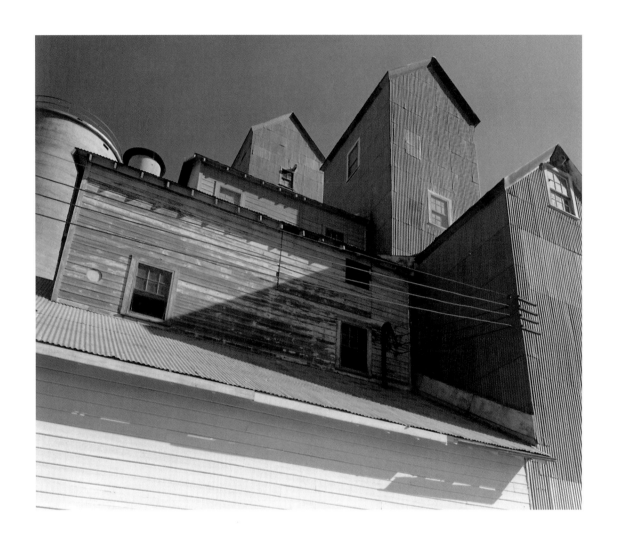

Rosalia Producers, Inc., elevator 415A, Rosalia, Washington

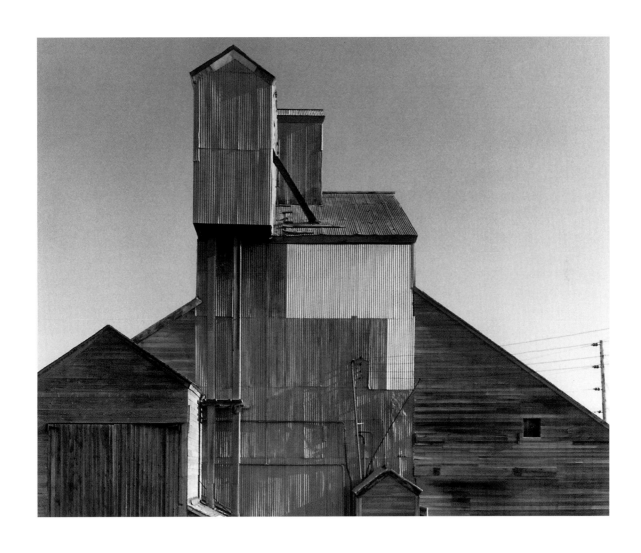

Dumas Seed Company elevator, south of Pullman, Washington

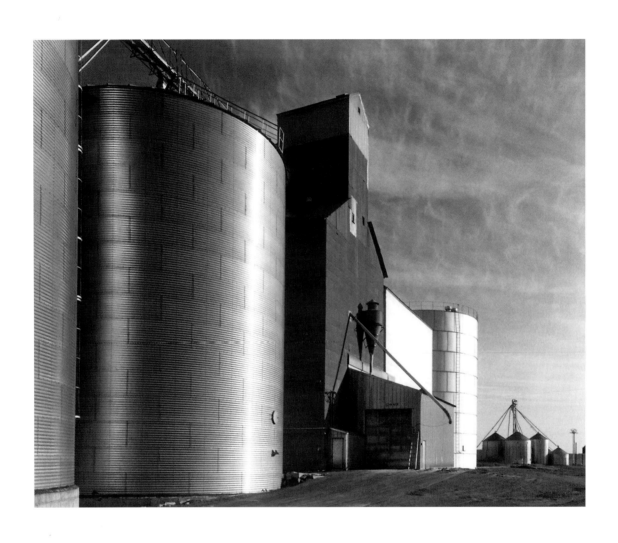

Latah County Grain Growers elevator 263, Viola, Idaho

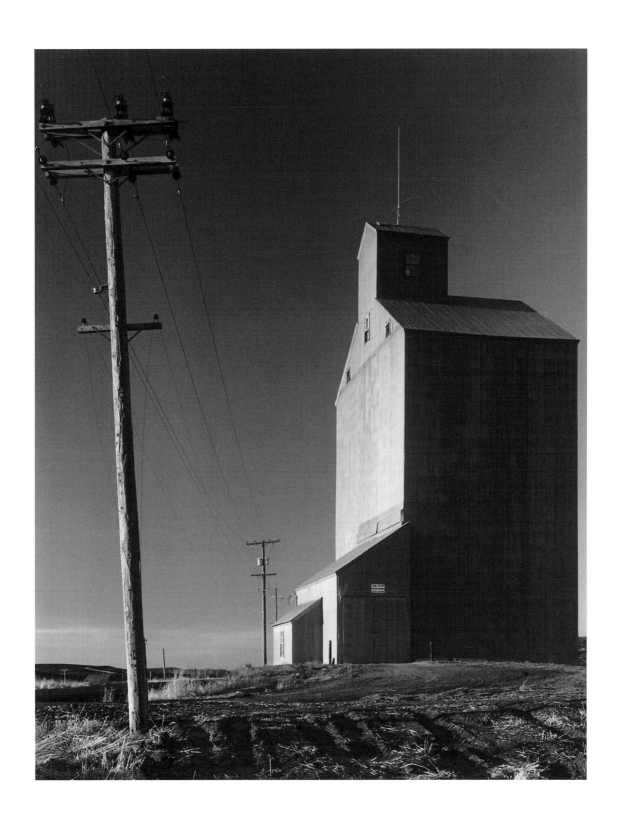

Henry Fisher elevator, south of Belmont, Washington

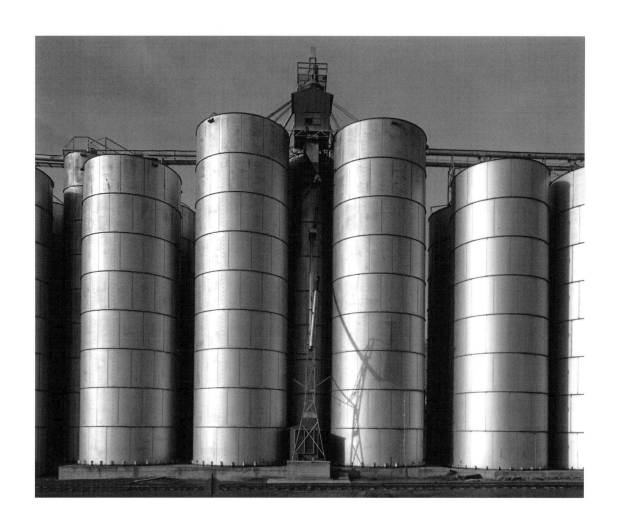

Pomeroy Grain Growers, Green Berry Station, Pomeroy, Washington

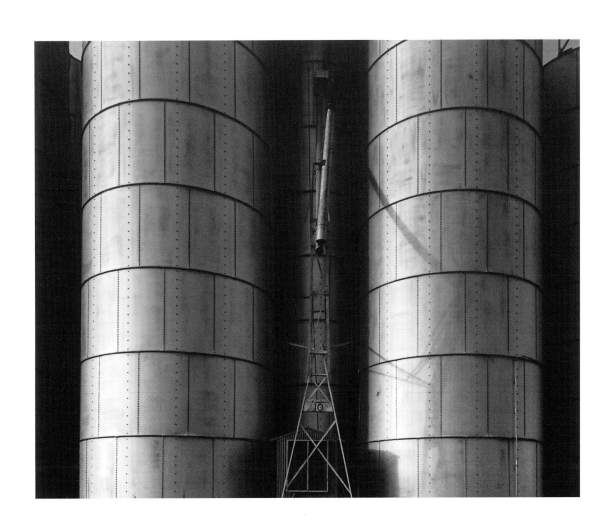

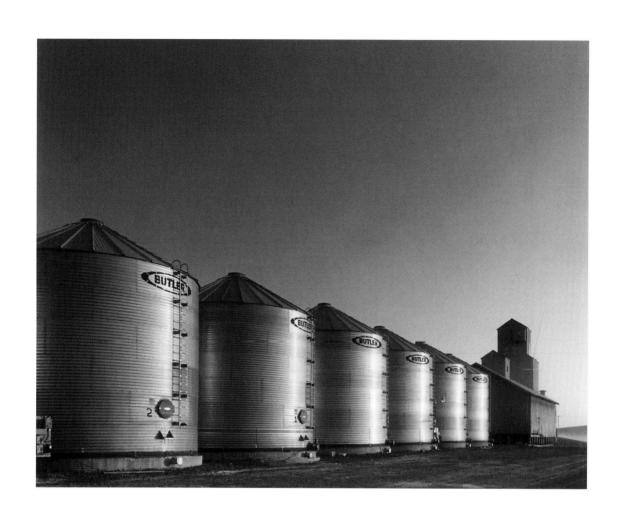

Staley, Washington

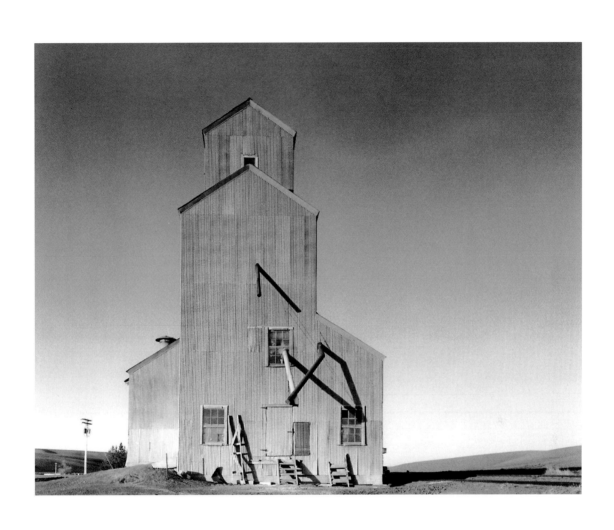

Staley, Washington

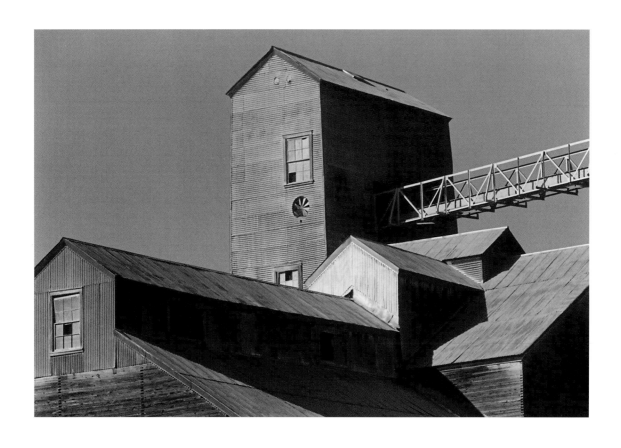

Whitman County Grain Growers elevator 95J, Pullman, Washington

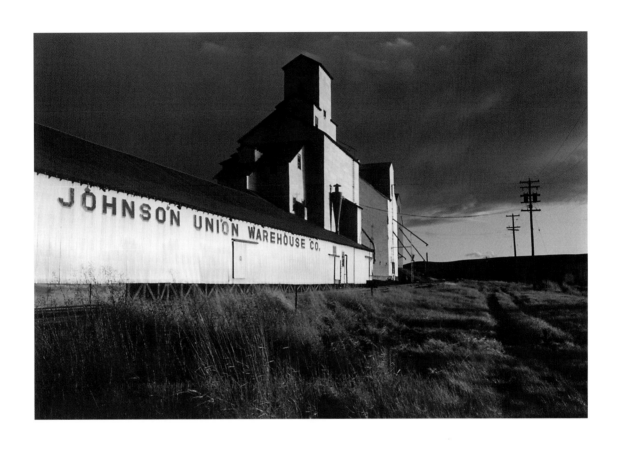

Johnson Union Warehouse Company elevator, Johnson, Washington

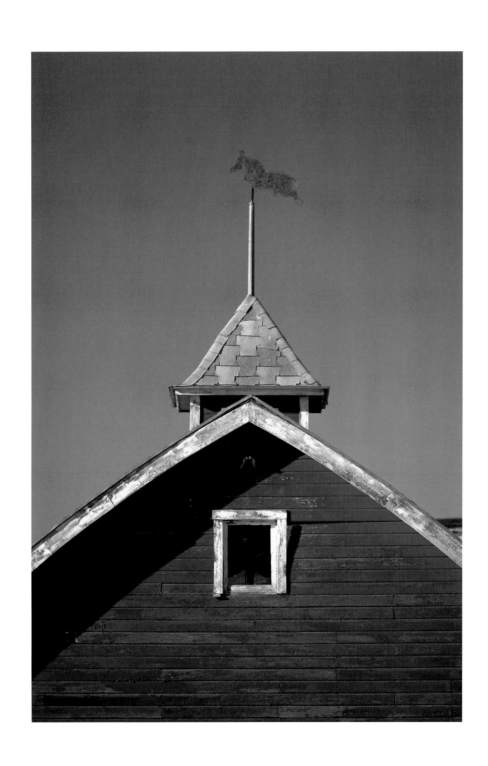

Jorstad barn, east of Pullman, Washington

61

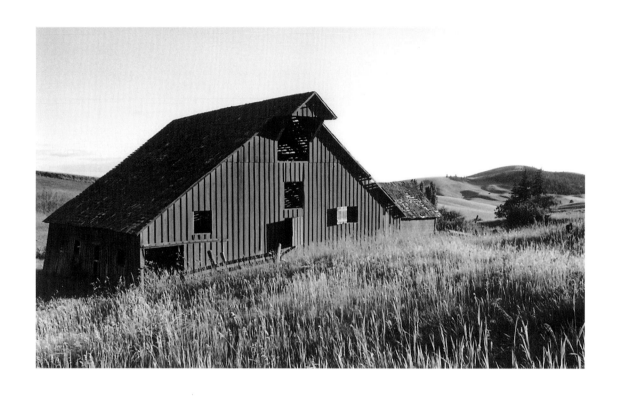

Ralph Thompson barn, north of Viola, Idaho

62

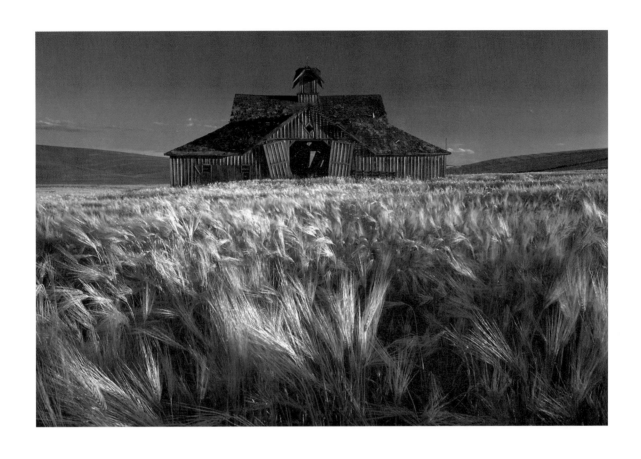

Sharon Hanford barn, Whitman County, Washington

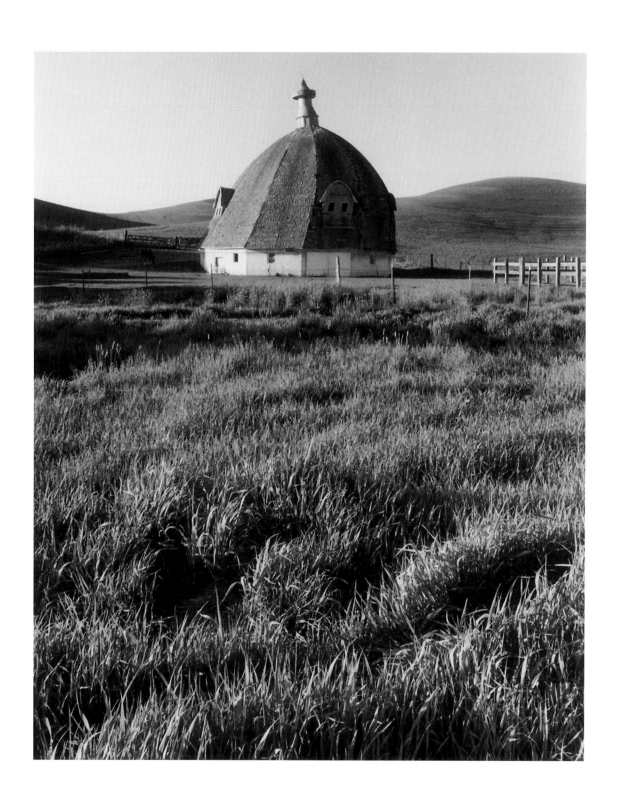

Richard Hall barn, west of Steptoe, Washington

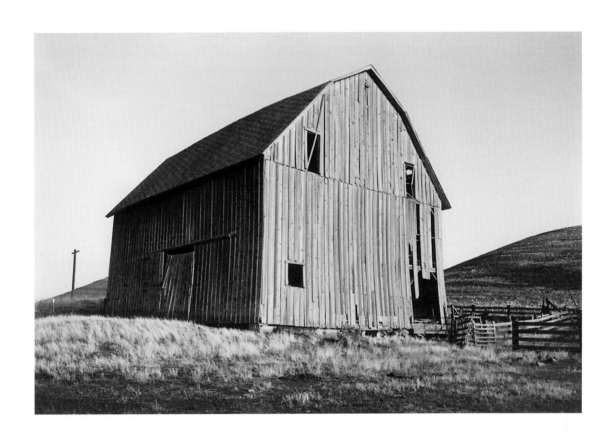

Duveen Kosola barn, Whitman County, Washington

65

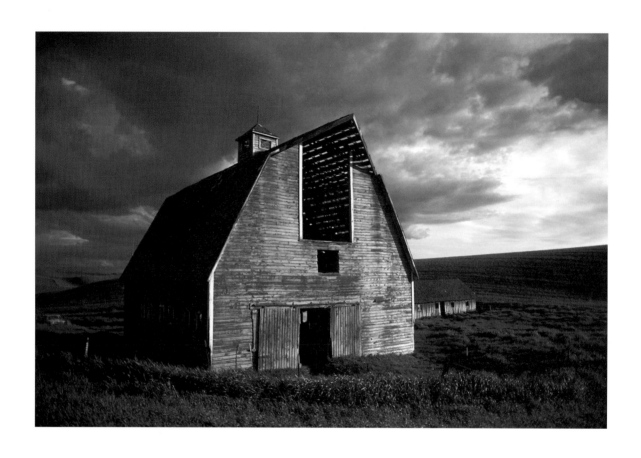

Steever barn, northeast of Pullman, Washington

Harold Kamerrer barn, west of Pullman, Washington

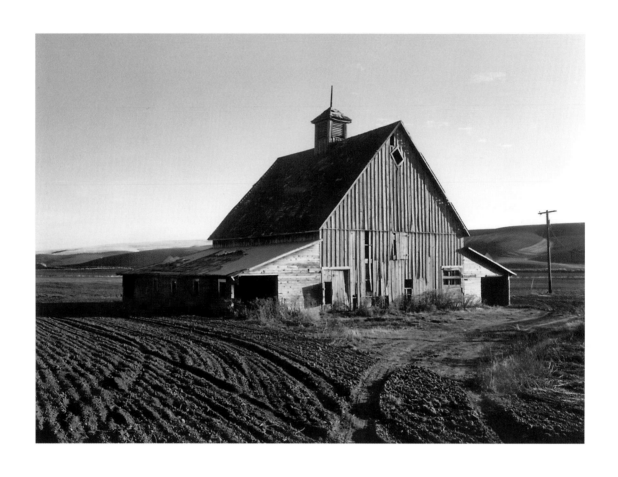

Tommy Williams barn, east of St. John, Washington

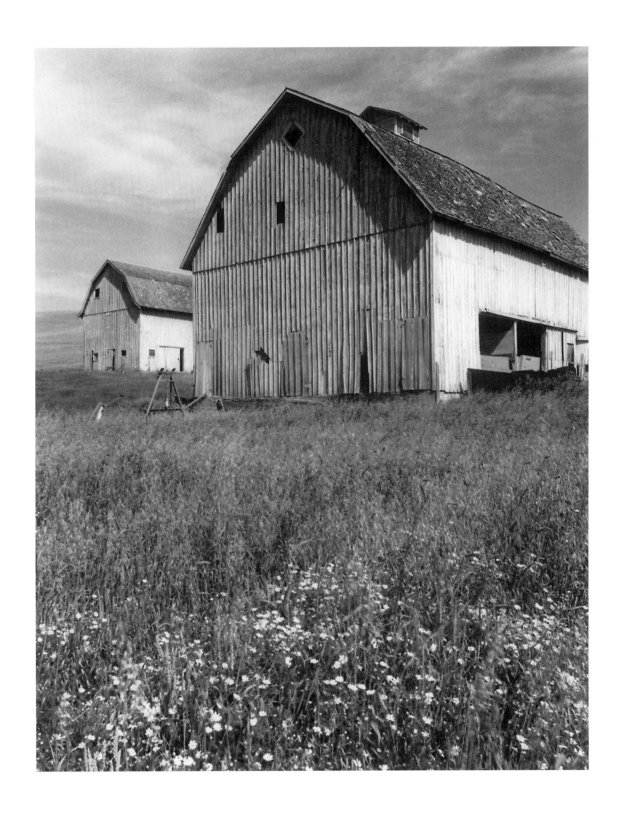

Robert Young barns, west of Pullman, Washington

69

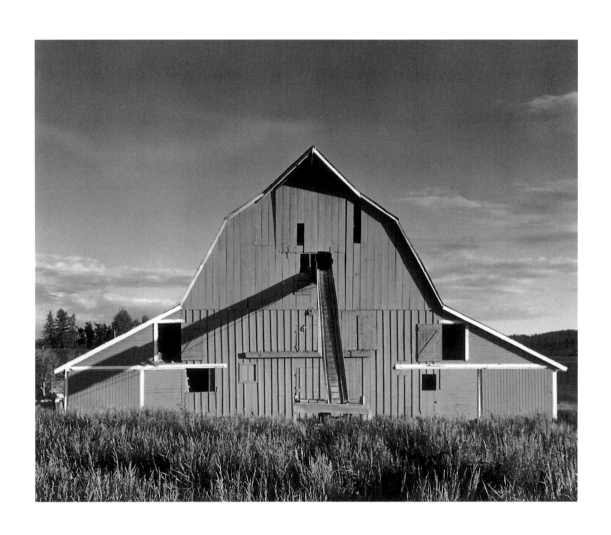

Hugh Vandemark barn, southwest of Potlatch, Idaho

70

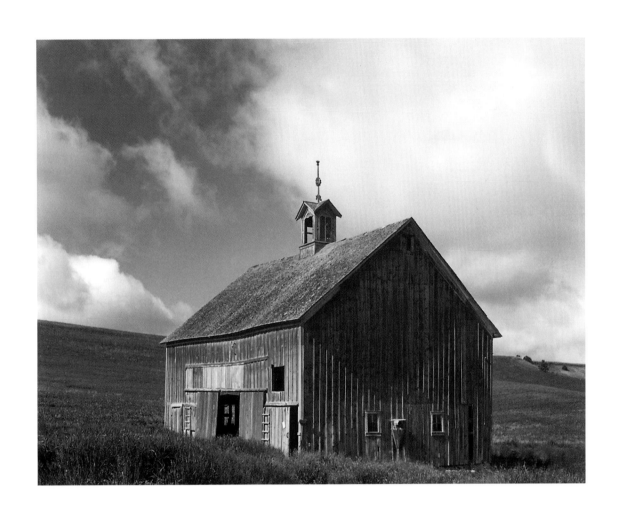

Elmer Blackman barn, Whitman County, Washington

71

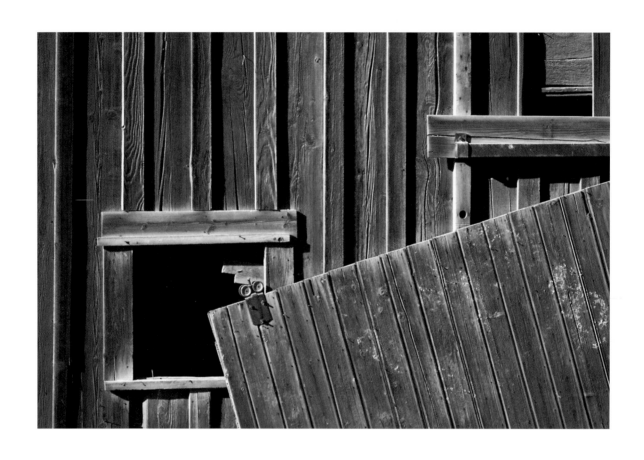

Terry Walser barn, southwest of Potlatch, Idaho

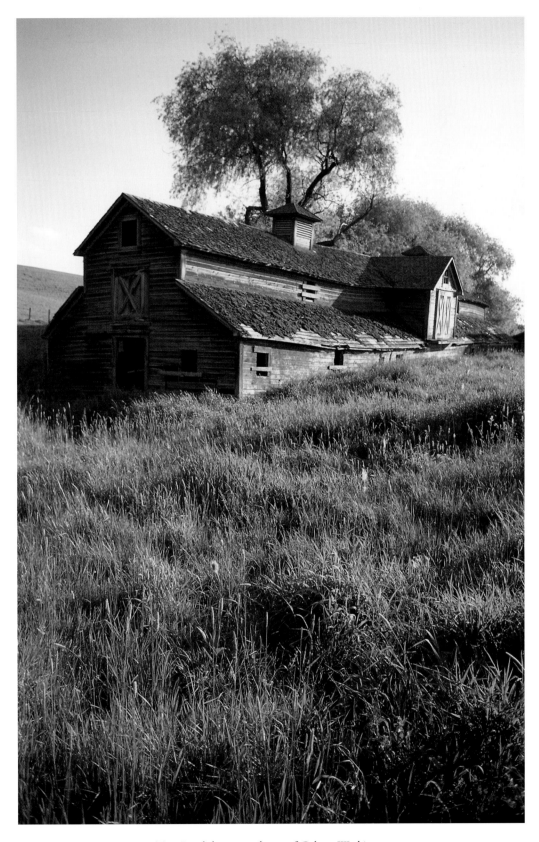

Tom Busch barn, southwest of Colton, Washington

73

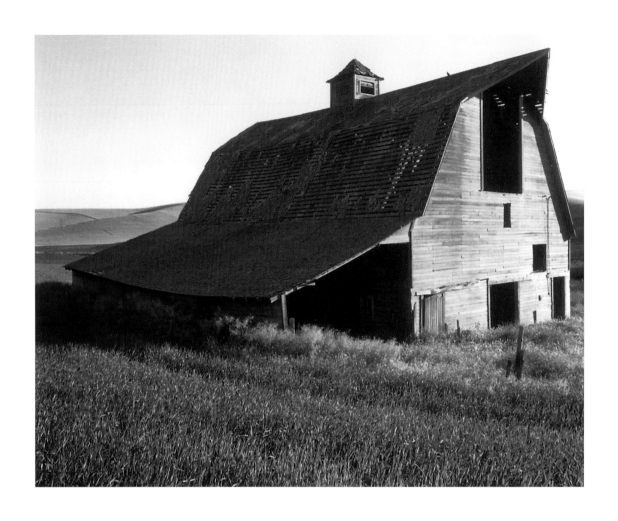

Eugene Brannon barn, Whitman County, Washington

74

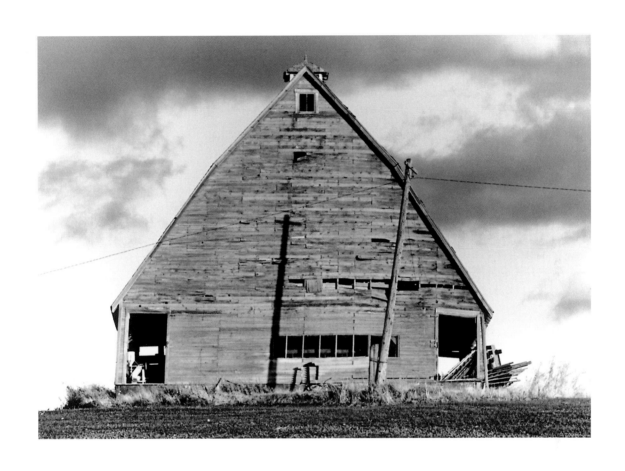

Thelma Gray barn, Viola, Idaho

75

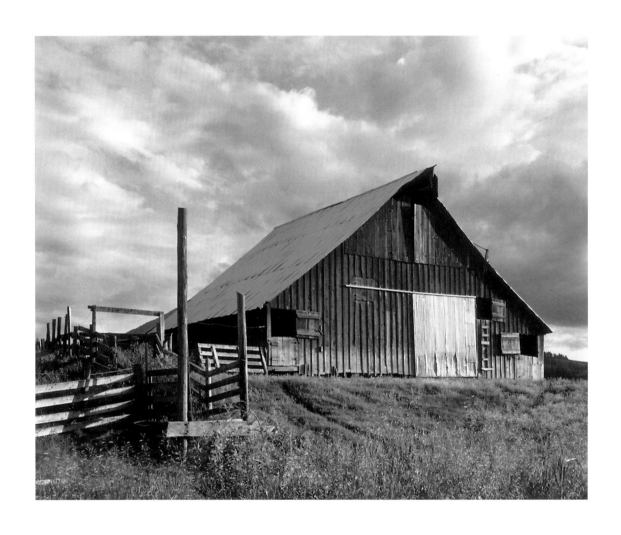

Catherine Walker barn, southwest of Potlatch, Idaho

76

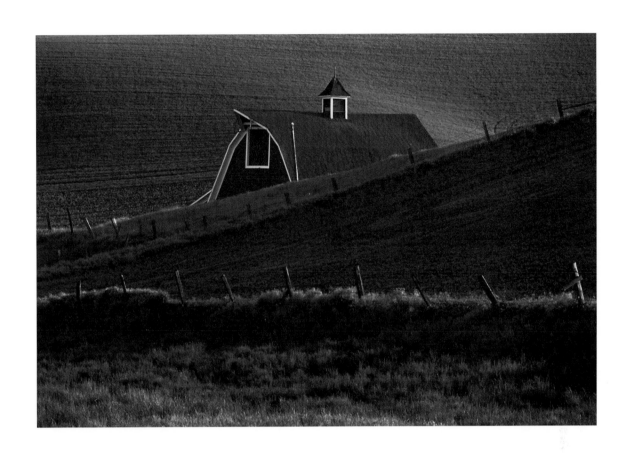

Craig Willson barn, north of Colfax, Washington

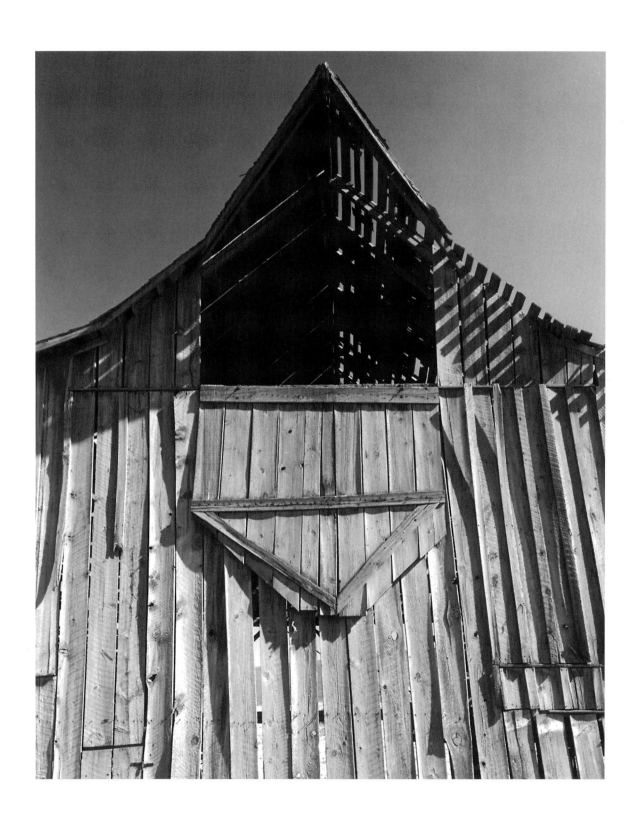

Earl Mohr barn, southwest of Colfax, Washington

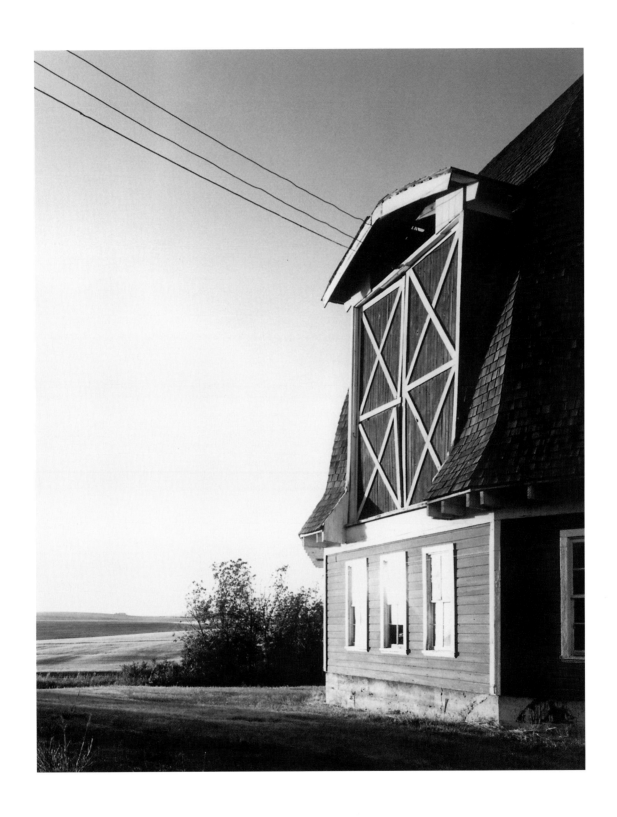

T.A. Leonard barn, east of Pullman, Washington

79

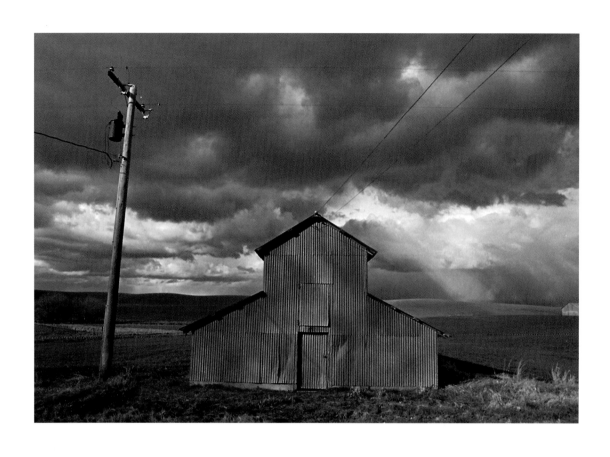

Carothers barn, west of Pullman, Washington

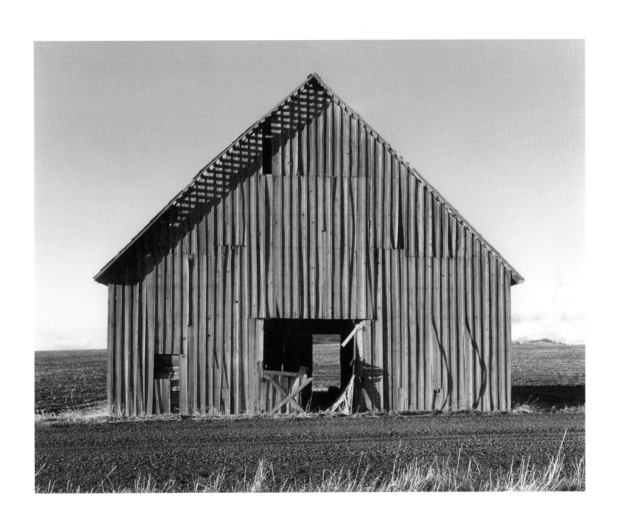

Lowell Hargus barn, Whitman County, Washington

81

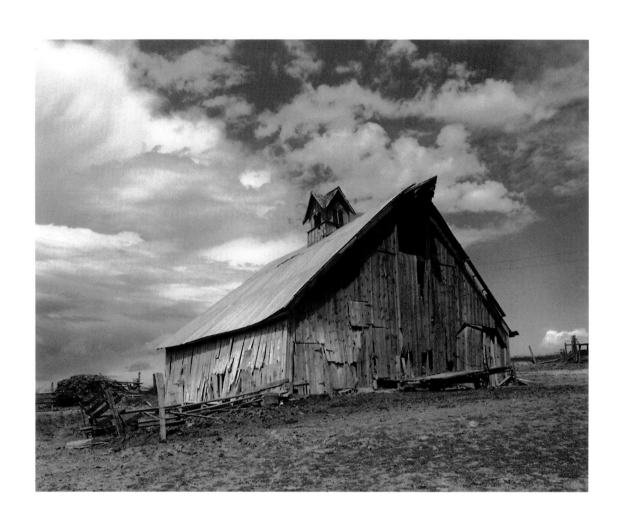

Matt Mengelkamp barn, near Joel, Idaho

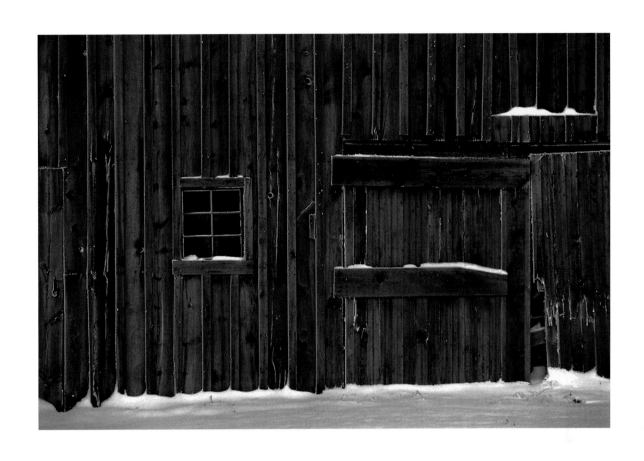

Richard McCroskey barn, north of Pullman, Washington

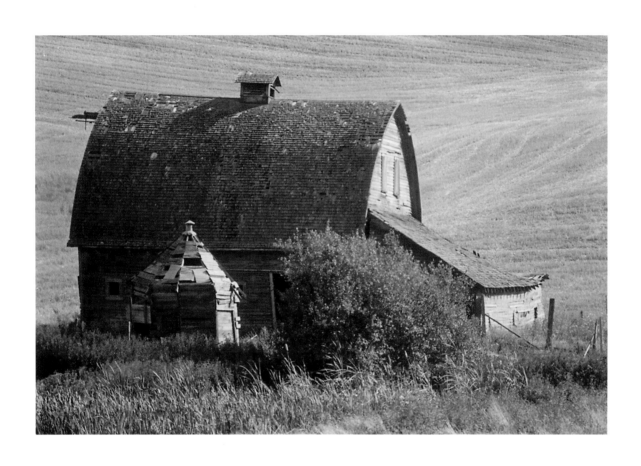

Elsie Blane barn, northeast of Potlatch, Idaho

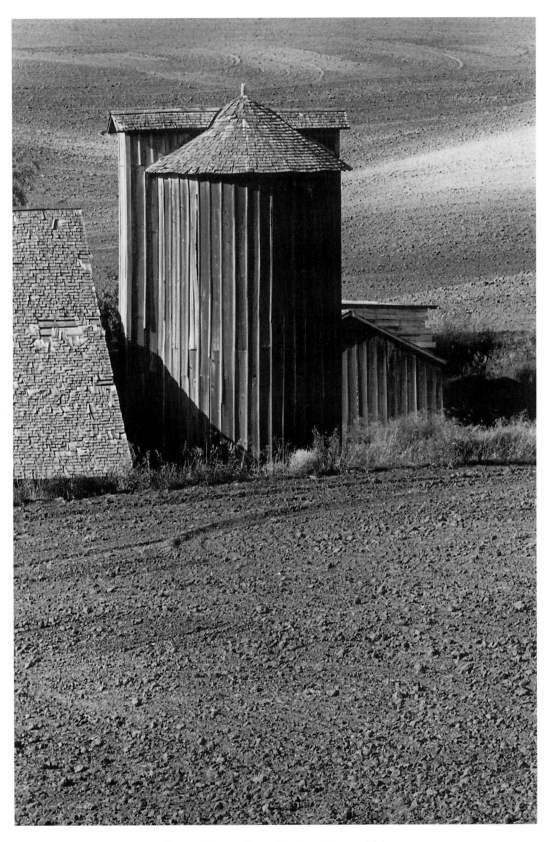

Leonard Beavert barn, Nez Perce County, Idaho

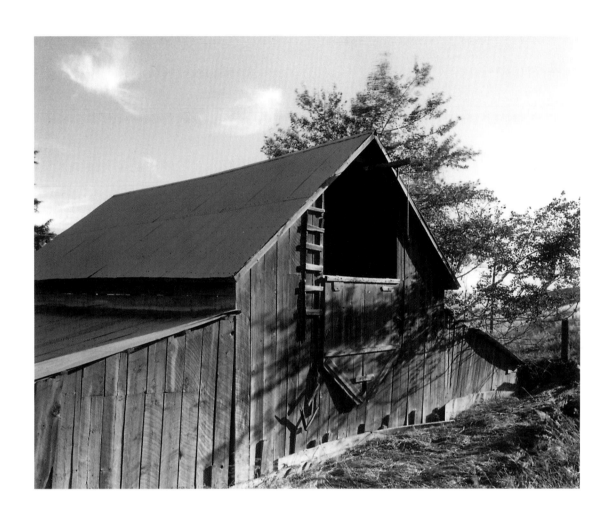

Marvin Link barn, Whitman County, Washington

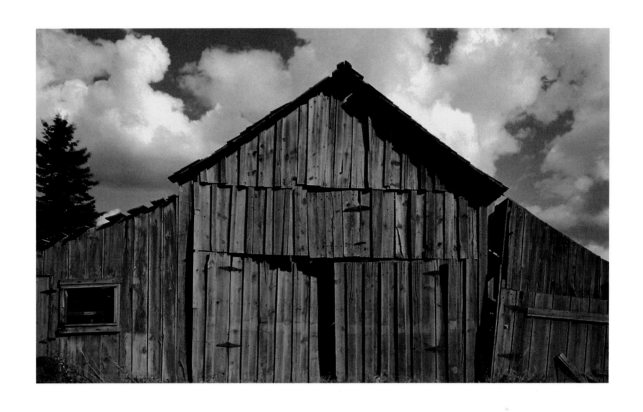

Norman Kunze barn, Diamond, Washington

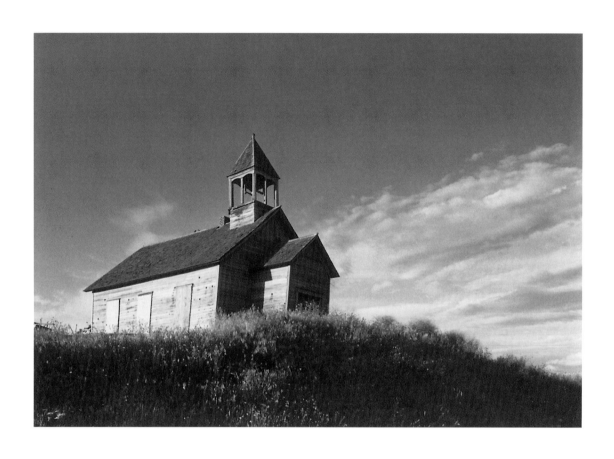

Ansie Askins barn, formerly the Skeens School, Whitman County, Washington

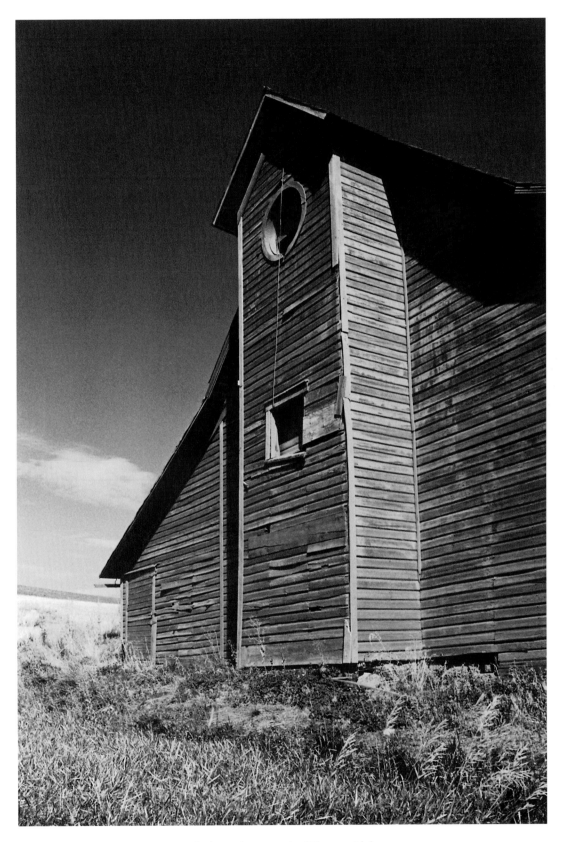

Anderson barn, north of Genesee, Idaho

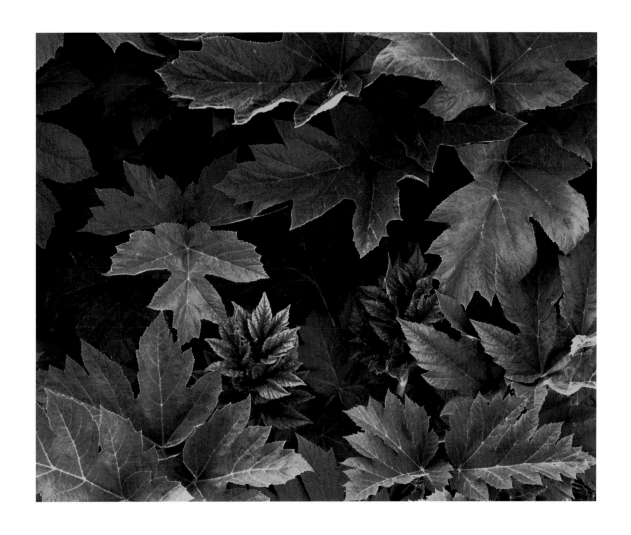

Cow parsnip, Kamiak Butte, Whitman County, Washington

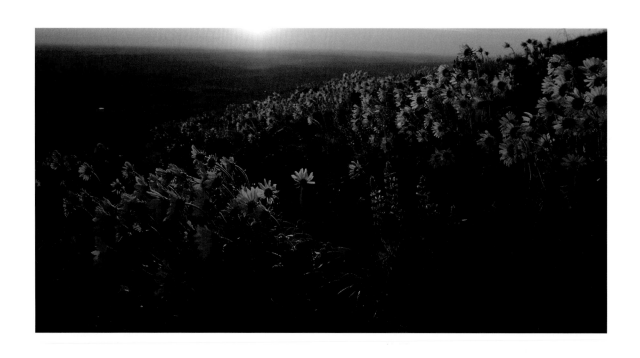

Balsamroot and lupines, Steptoe Butte, Whitman County, Washington

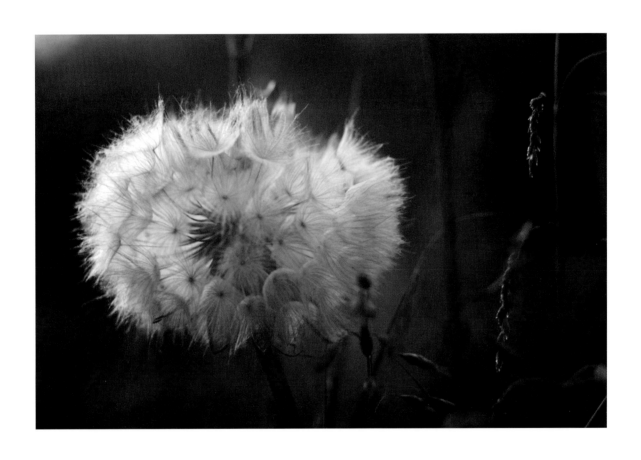

Salsify, Latah County, Idaho

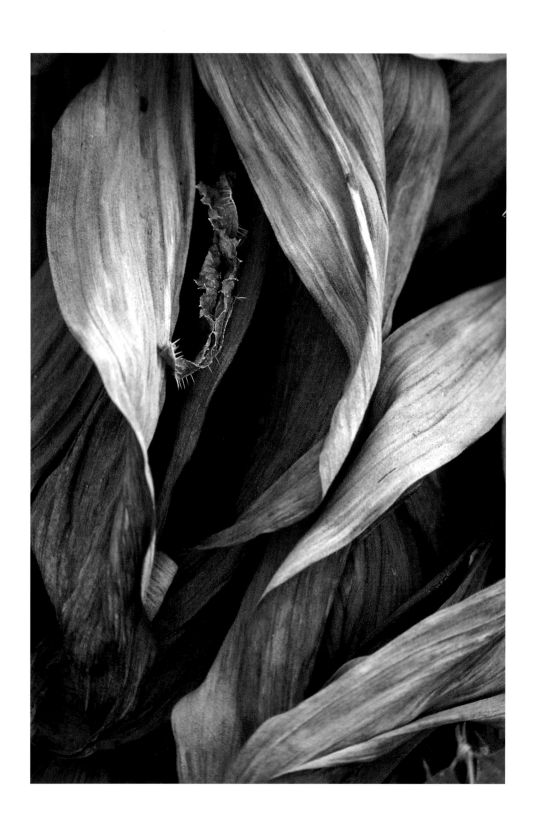

False hellebore and a fragment of prickly lettuce, Latah County, Idaho

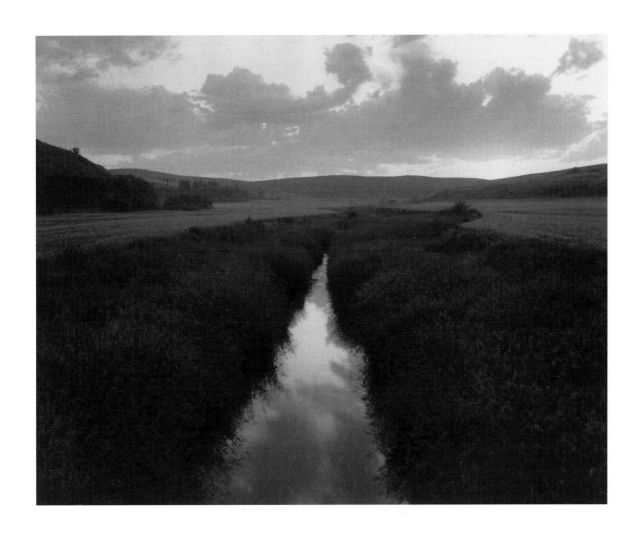

Union Creek, Whitman County, Washington

95

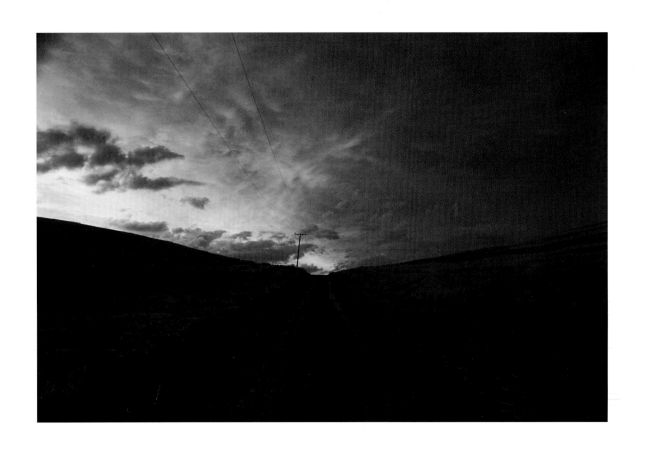

Smith Road, Whitman County, Washington

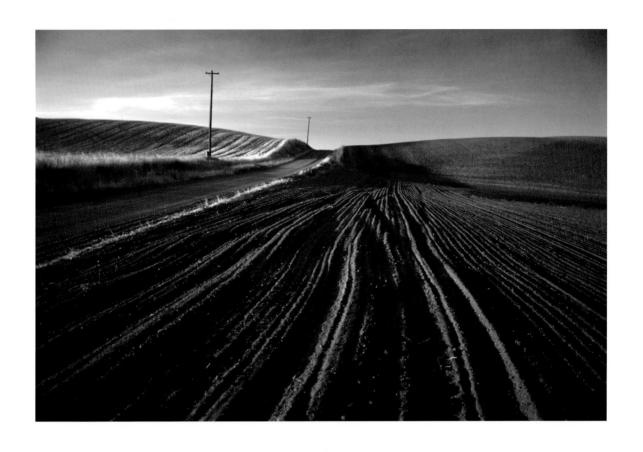

Abbott Road, Whitman County, Washington

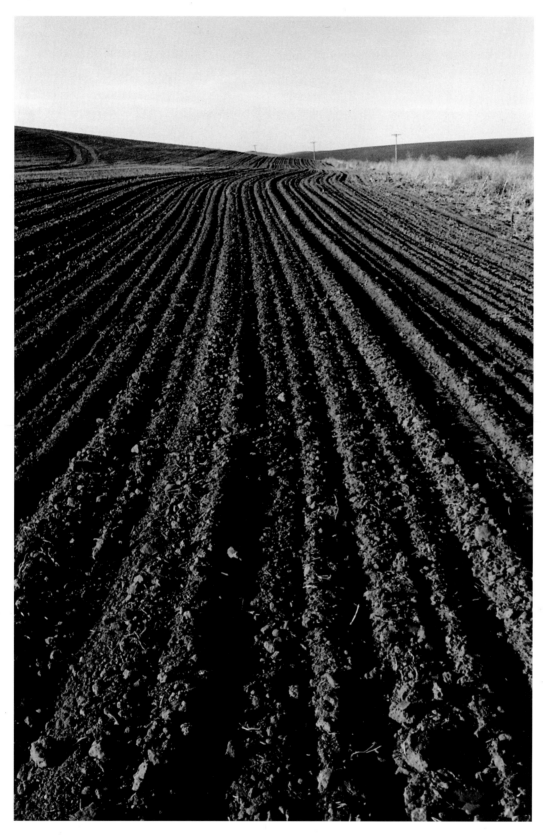

Plowed field, Staley, Washington

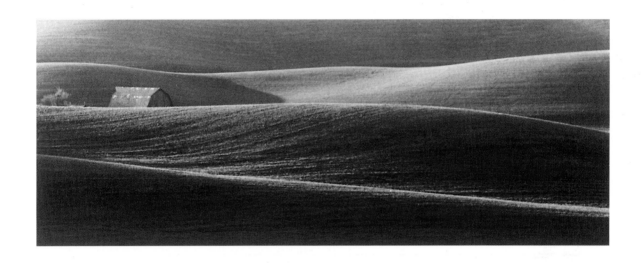

Hillscape west of Pullman, Washington

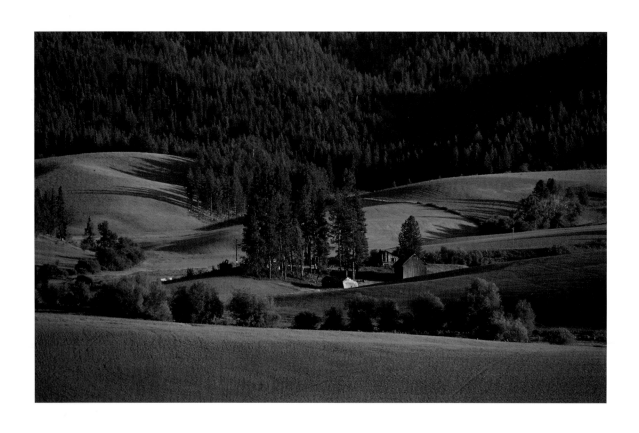

Landscape southwest of Potlatch, Idaho

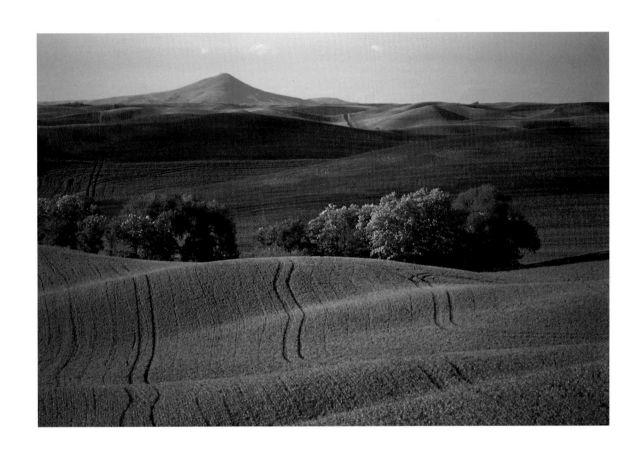

Landscape west of Pullman, Washington

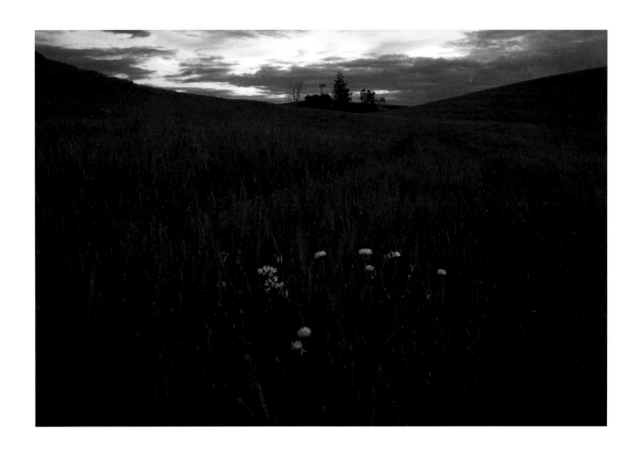

Wheatfield with cornflowers, Latah County, Idaho

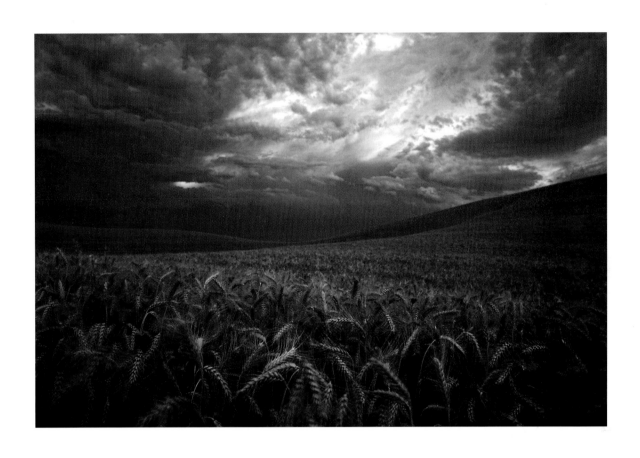

Wheatfield, Whitman County, Washington

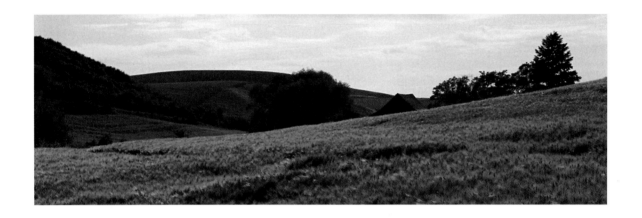

Wheatlands, Whitman County, Washington

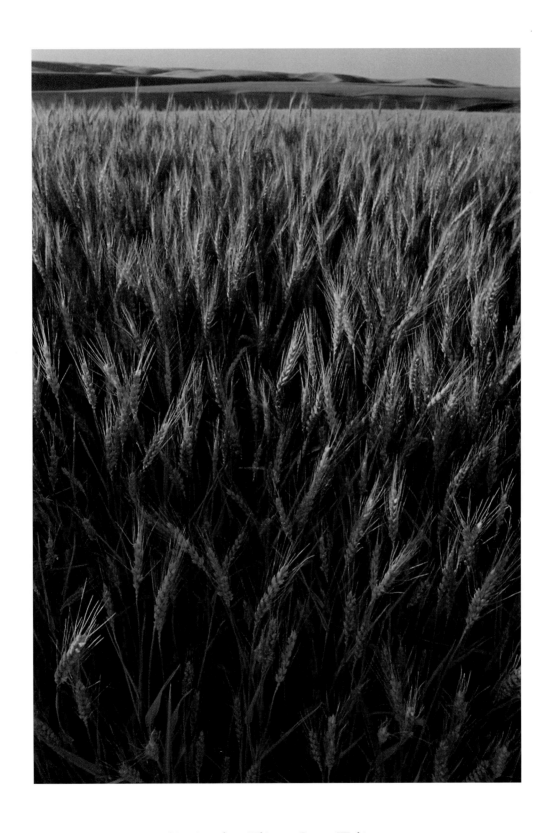

Ripening wheat, Whitman County, Washington

105

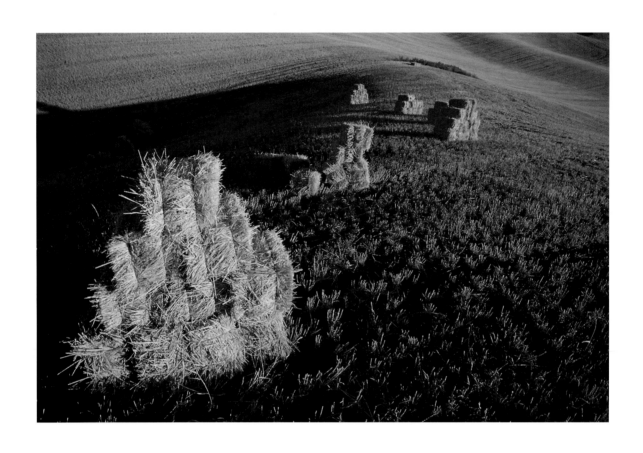

Hay bales, Whitman County, Washington

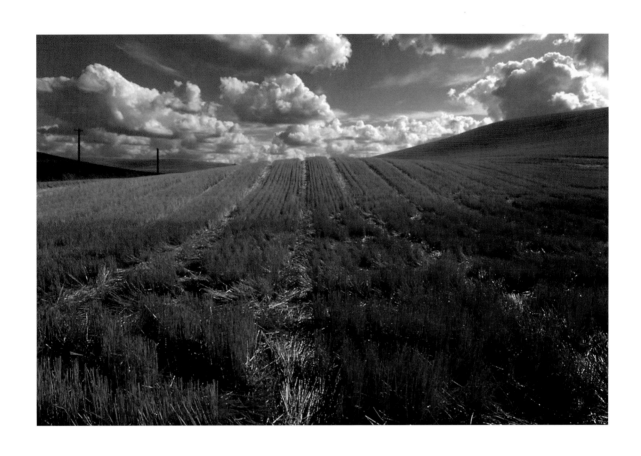

Stubblefield, Whitman County, Washington

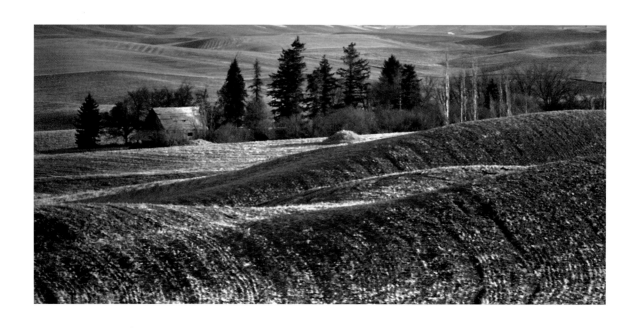

Fields in frost, north of Pullman, Washington

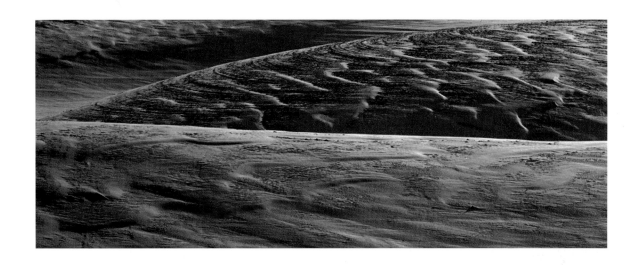

Winter hillscape, north of Johnson, Washington

109

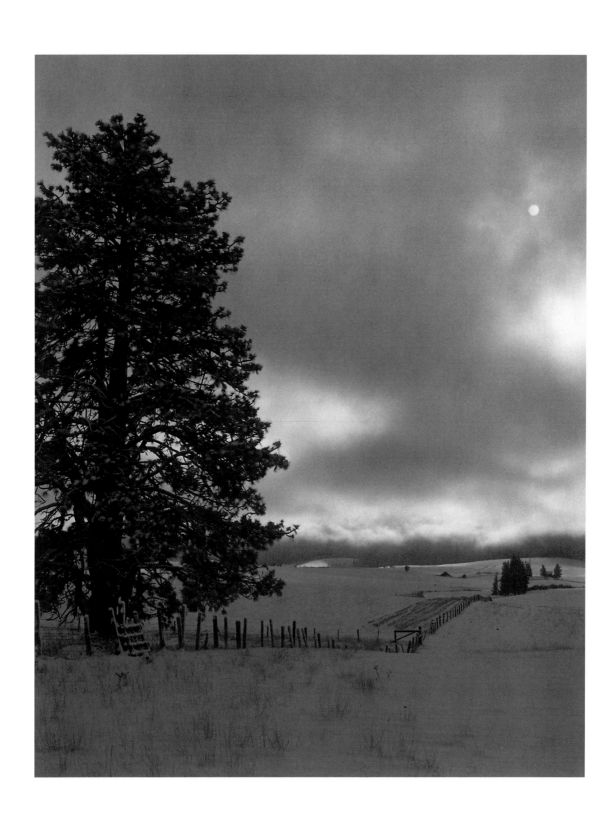

Pine, fence, and fields, Latah County, Idaho

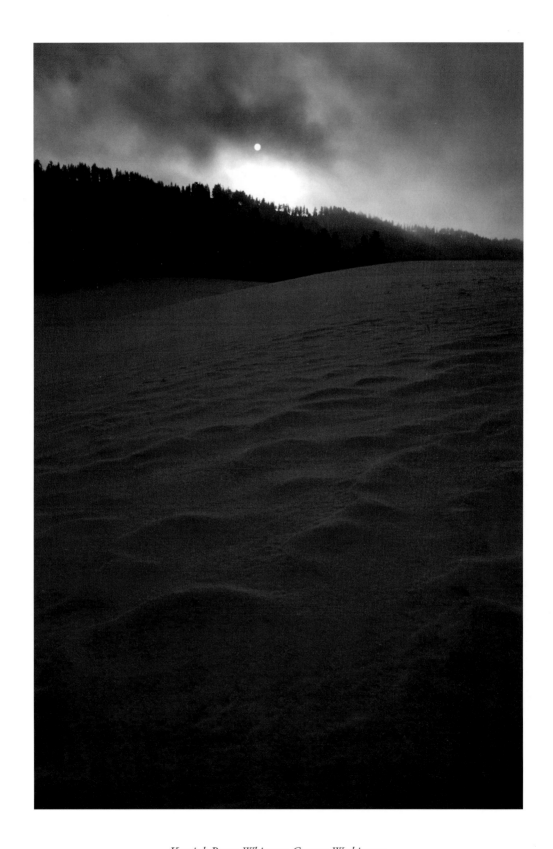

Kamiak Butte, Whitman County, Washington

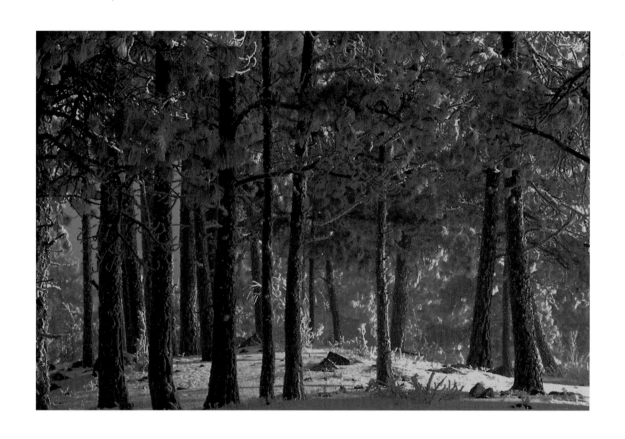

Pines in frost, Kamiak Butte, Whitman County, Washington

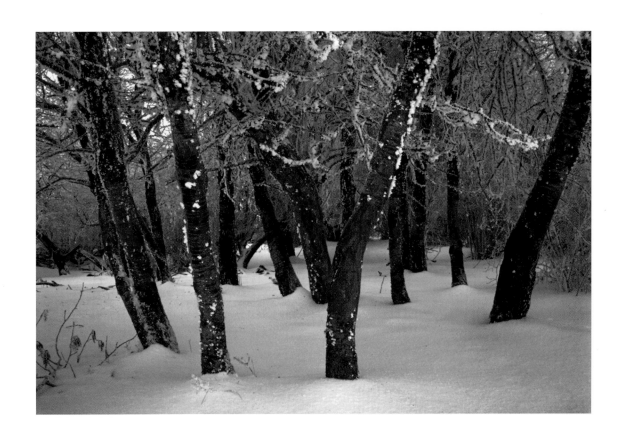

Aspen grove, Steptoe Butte, Whitman County, Washington

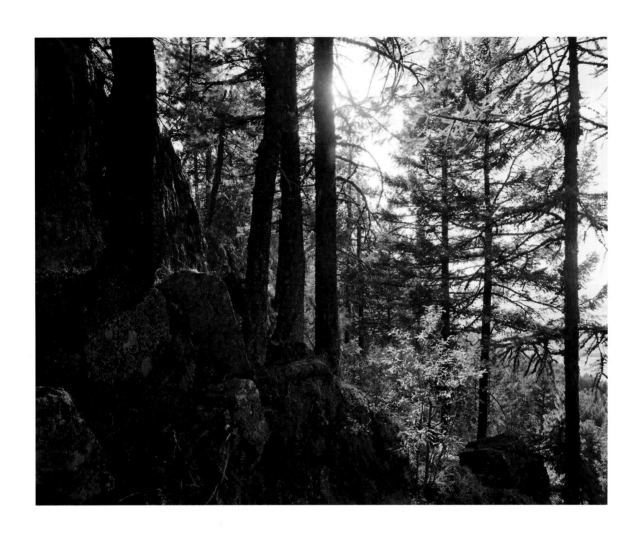

North slope of Kamiak Butte, Whitman County, Washington

114

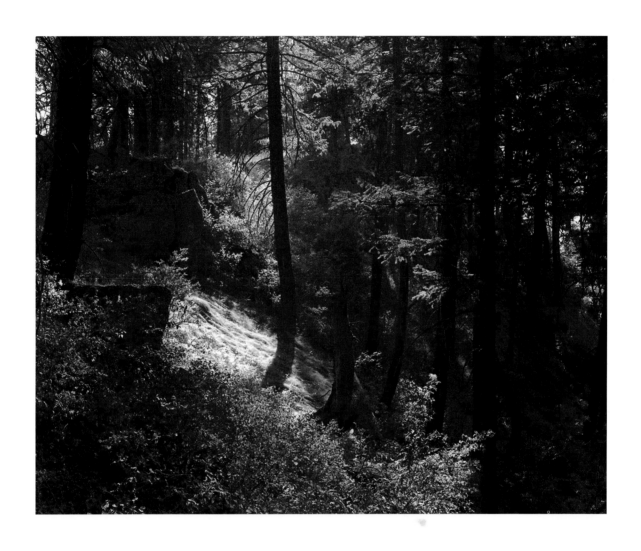

North slope of Kamiak Butte, Whitman County, Washington

115

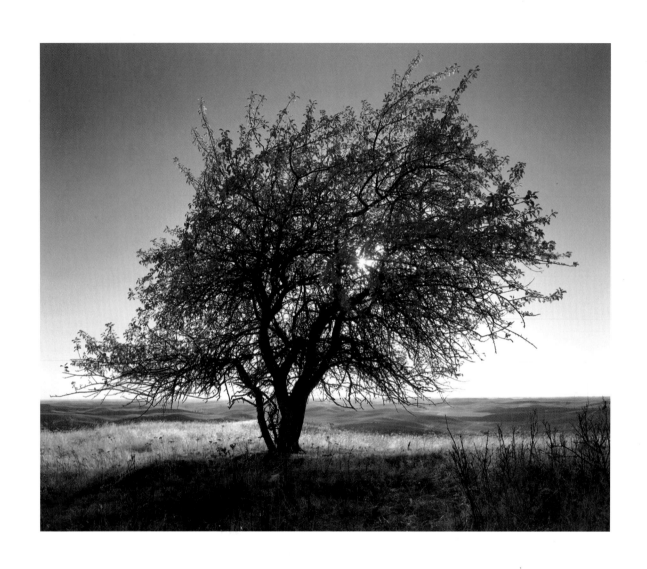

Apple tree, Steptoe Butte, Whitman County, Washington

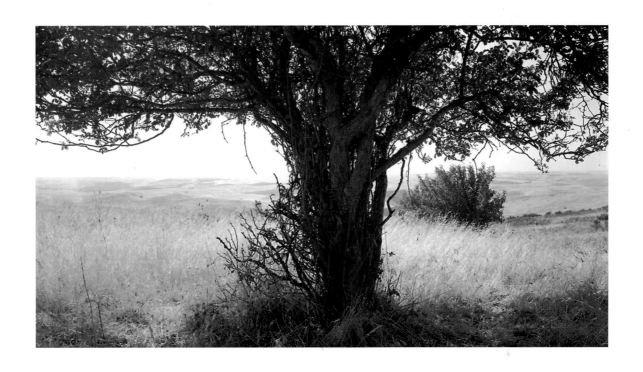

Steptoe Butte, Whitman County, Washington

117

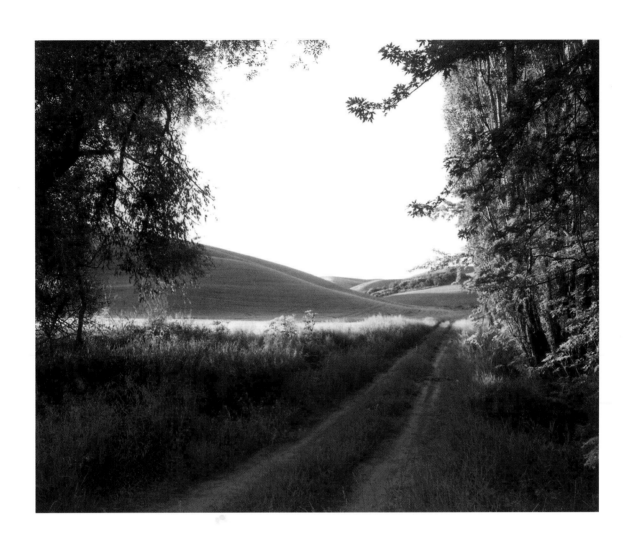

Off the Goose Creek Road, Whitman County, Washington

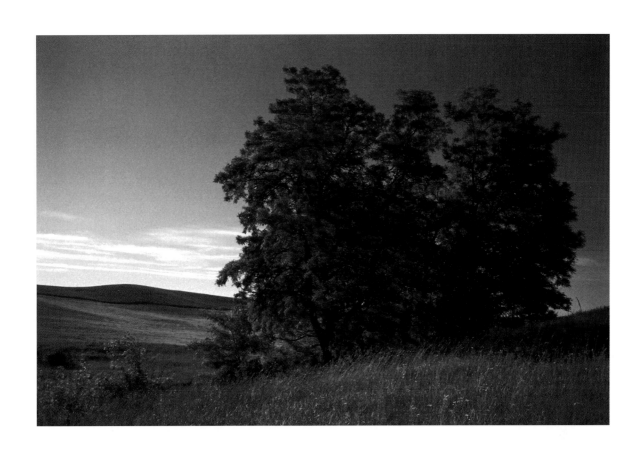

Black locust grove, Whitman County, Washington

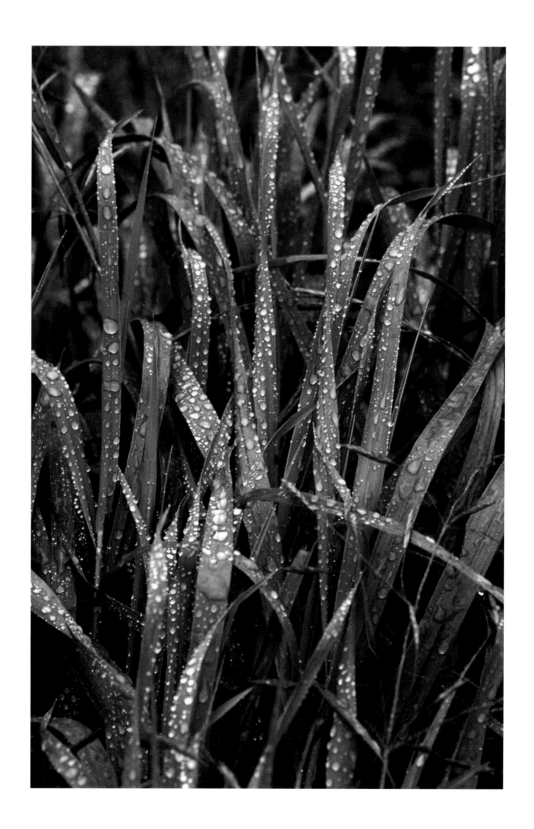

New grass, Latah County, Idaho

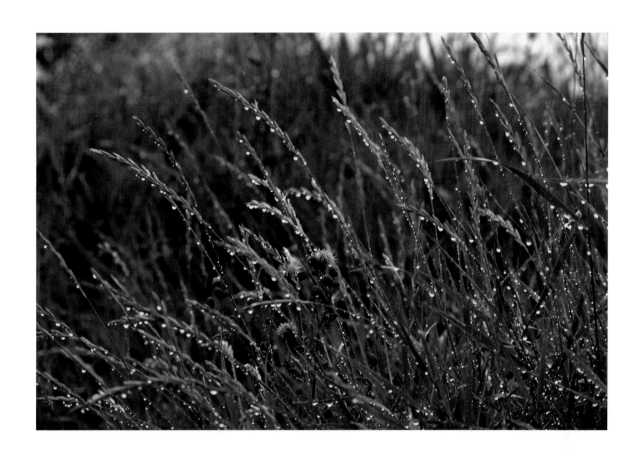

Grass and thistles, Latah County, Idaho

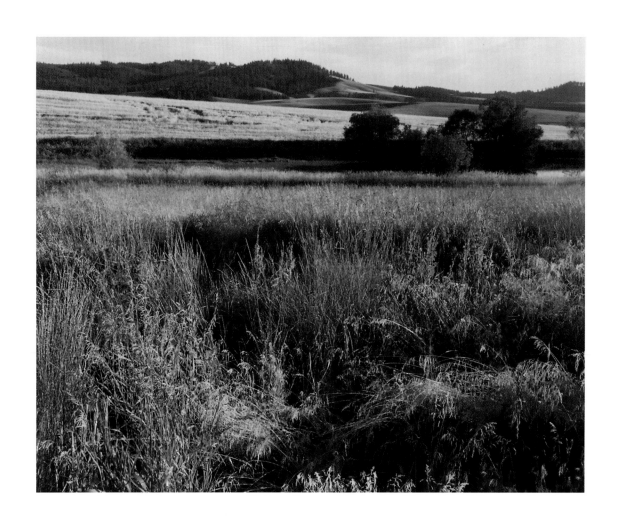

Grassfield and Ball Butte, Latah County, Idaho

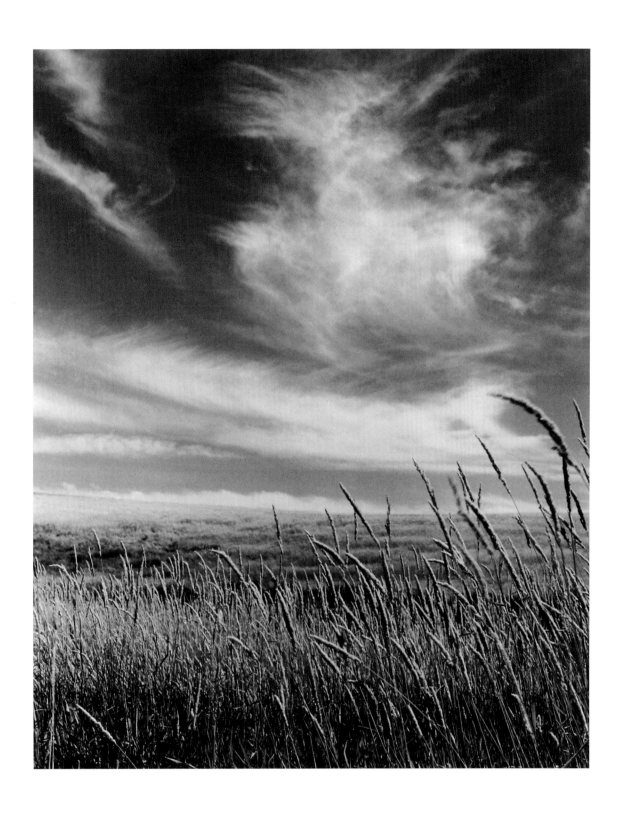

Grass and clouds, Latah County, Idaho

123

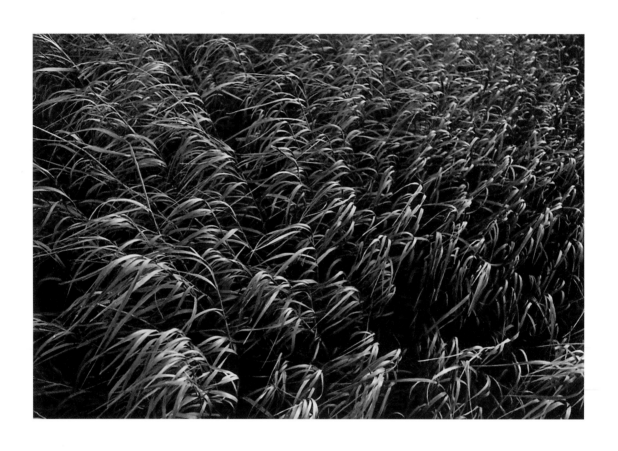

Dry grass, Whitman County, Washington

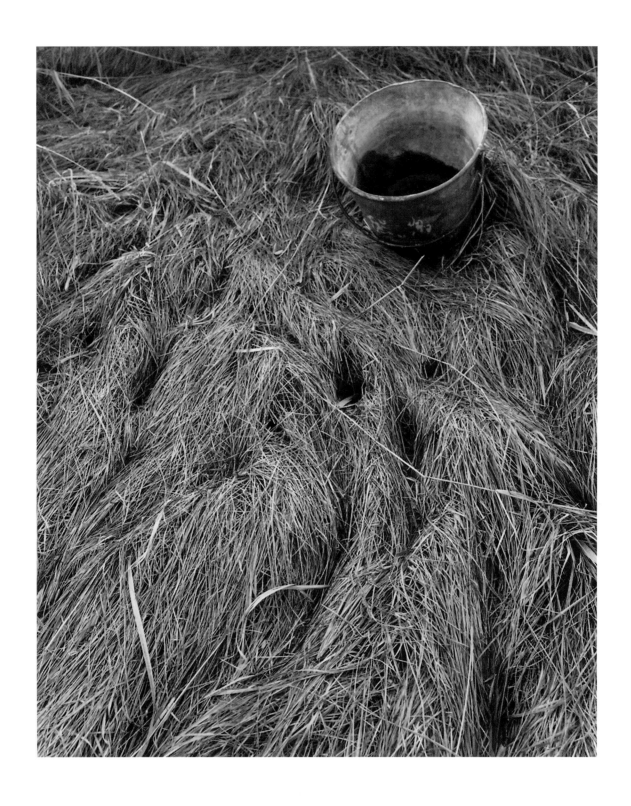

Grass and pail, Latah County, Idaho

GEORGE BEDIRIAN:
RESTORING THE MYTH OF LOCALE

Terry Lawhead

The roads of the Palouse are deliriously pleasant to walk, as they rise and fall and wind around the flowing hills. But human ambition being what it is, we usually need a good reason to walk.

I had no lack of reasons during my first three years in the Palouse. Desiring seclusion, I chose out-of-the-way places to live—places I could only walk through to get home, partly because of the nature of the roads—primitive—and of my vehicles—old. A disadvantage to such places was the amount of time it took to get to them. A benefit was that I was never able to fall into that lazy complacency of driving home, getting out of the truck and going into the house unaware of what was happening in the landscape and sky.

As I walked to my end-of-the-road homes, growing more familiar with the landforms of the Palouse and learning about their geology and history, seeing the hills in many hues and shades, certain scenes became as familiar to me as my close friends. Such scenes needed to be understood to be appreciated, I felt, because there was an unanticipated depth and complexity about them that was only revealed over time.

In those days, I rejected landscape photography, in the belief that such work reflected a lack of appreciation for what truly takes place on the land. It was a supremely arrogant stand by a young man who chose to work at farming and who felt that any ground you did not drip sweat onto was ground you did not truly know. And the marketplace was awash with photographs of romantic rural scenes for people who never knew rural life and never would, but who displayed them on their walls for graphic relief from the grotesqueness of urban life.

So I rejected exploitation, the easy shot of a handsome person, as it were. Because the hills *were* handsome in every season. They were beautiful friends taken advantage of by people who didn't know them and who never asked if they could sing. They could. I knew, because I had awakened to so many glorious mornings among them, passed so many exhilarating afternoons and melancholy nights in their company—too many to allow them to be summed up in a quick, cosmetic shot, without a fight.

But as fate would have it, my hermetic belief was broken apart the first time I saw a photograph by George Bedirian. It was hanging in a small alcove at the Washington State University archives, unseen by the majority of people using the library. The photograph was of a barn set at the crest of a low hill, seen from below. It was a reverent perspective, made more so by the setting sun illuminating the barn and making it blaze with warmth and mystery and a gentle sense of solitude.

I was struck by that view, because I had seen it myself. Not the same barn, although it took a close inspection to be certain it wasn't, but the same light, the glow of the wood, the piercing depth of the evening sky darkening behind it. I looked for the name of the photographer, certain it was not a snapshot by a local farmer, but amazed that anyone else would have had an eye for the scene, or the implied patience to wait for it to show itself.

Looking at George's blazing barn, I remembered my own experience: walking up out of a shadowed draw to see a flash of brilliant light out of the corner of an eye, and turning to gaze upon the peak of a lit barn, the steep dark shingled roof cutting the light at a sharp angle, the eastward sky deep turquoise. Just the top peak was visible, and not another object was in light. I walked on, fast, to get out of the shadows and see more.

The barn was a magnificent ruin, equal to the esteemed temples of Western heritage. Except it was the Olsons' barn, and I knew what was in it. I had in fact helped the Olsons put up their hay and had approached the barn many times from the other side for tools and to find the father and son. It was a familiar landmark on my journeys home, a reminder I was almost to my own place and could start to relax. And here it was about to speak in tongues. I watched as the light faded, the sun vanishing below the west horizon. The barn remained now, gray and silent, showing its age and practical nature. But for one glorious moment, it had shown another face.

George's photograph returned me to a personal experience I could never have conveyed to another person, because there was nothing to be done in the telling—it was all visual. I appreciated that he could do that, and that he knew something I had grown to know. And I marked him down as someone who was doing something right on the back roads.

A captured image embodies a way of seeing by the photographer. George takes great pleasure in what he sees, and returns again and again for more seeing. In his repeated returns, he reenacts the lifetimes of returning home, of routines in our lives, and the growth of the feeling of sanctuary in familiar landscapes. He says a wonderful thing about such habits: "The Palouse gives me a lot of visual delight, and I want to record that. What I love to do is arrest that moment of delight."

But the delight is tempered by a shaping mind. Having taught English at the University of Idaho and elsewhere, George brings a rich literary background to his appreciation of the Palouse landscape. The selection and composition of his photographs reveal a trained imagination and intellect, one used to complexity and in fact preferring it. "A good photograph, like a good poem," he writes, "has levels of meaning which transcend the literal, that resonate with suggestions not present in the thing photographed."

Susan Sontag said photography makes reality disconnected, throwing it together in ways it wasn't meant to be. All art runs this risk, of course, because it is once removed from direct experience and altered to reflect the artist. But with his sense of form, George puts materials together at his discretion and produces a work of continuity, a whole. A story. And while he claims no literary aspirations, he puts into his photography a rare intensity of form akin to poetry.

Photographs offer a strong testimony about the world, offering images more precise, more penetrating that those of literature. We situate ourselves in landscapes and complete the witness.

Hundreds of years ago in the West the Indians had a rich mythology drawn from plant and animal life. Their precise knowledge of the places they inhabited informed these myths, so they were not fantasies. Their stories were concrete embodiments of the land itself, told through the imagination, and every return to a story or place reaffirmed that sense of place.

Art is a strong tool of mythology today. It is also a fragile one, easily manipulated to betray us with false information. My past rejection of landscape photography stemmed from the conviction that it left us without an adequate frame of reference. But because our own sense of land is broken, art supersedes our knowledge, and therefore can locate us in space and time, healing our wounds of loneliness and estrangement from the past.

And this is what George's photographs do, rooted as they are in the familiar, commonplace elements of life in the Palouse. Nowhere is this more evident than in his images of small town streets and buildings. The townscape—even the landscape—is domestic, showing the work of care, cultivation, and use. Because these churches, warehouses, shops, and streets are of such comfortable human scale, we feel the presence of people, even though they are physically absent.

But it is really generations of people that are present here. In these photographs the past is pulled up for view with an uncompromising rawness, but retaining a mystery, as places of habitation must. Nothing is assured, ever—like being in your bed in the middle of the night, feeling safe and snug, when the light in the basement suddenly goes on.

These images allow us to admit this depth existing in the commonplace, to walk out of sight of home, to return at a quiet hour of dusk, and to see things for the first time.

A poem by Goethe suggests something of this:

There is a stillness
On the tops of the hills.
In the tree tops
You feel
Hardly a breath of air.
The small birds fall silent in the trees.
Simply wait: soon
You too will be silent.

This silence causes many things to happen. The landscape becomes more visible to our eye. And we are reminded that we are no different from the birds and the trees and that we too will die. There is first a little sadness at this, deprived of our blind spot which normally enables us to forget our mortality. But as our separate selves fade before this sadness, there is a twist, a leap, and we find ourselves more connected to the world than ever before. And there is an accompanying sense of happiness.

Landscape photography is included in the new basket of tools returning us to actual places, restoring the myth of locale. One must have faith in the photographer and his intentions; otherwise, the images are suspect.

In my case, I knew the subject first, and then found the documentation. I knew the Palouse and could see where George had been, can retrace his steps and stand where he stood. Nonetheless, I am amazed at what he is able to see. I still learn about my home from him.

What we have collectively lost is something we cannot consciously know, but we can identify it when we see it. Those who wish to walk might consider this book a map. Those who wish to more fully understand their walks might consider it a prayer.

38. *Abandoned commercial block*
Uniontown, Washington

39. *Abandoned frame buildings*
Uniontown, Washington (removed)

40, 41. *B and J Hardware and Grocery*
Winona, Washington (abandoned)

43. *Oakesdale Grain Growers, Inc. elevator*
Garfield, Washington

44. *General Mills Sperry Division elevator*
Winona, Washington

45. *J.M. and Carl Boyd elevator*
Whitlow, Washington

46. *Inland Empire Pea Growers seed plant*
Oakesdale, Washington

47. *Latah County Grain Growers seed plant*
Moscow, Idaho

48, 49. *Moscow Idaho Seed Company*
Moscow, Idaho

50. *Rosalia Producers, Inc., elevator 415A*
Rosalia, Washington

51. *Dumas Seed Company elevator*
highway 195 south of Pullman, Washington

52. *Latah County Grain Growers elevator 263*
Viola, Idaho

53. *Henry Fisher elevator*
highway 27 south of Belmont, Washington

54, 55. *Pomeroy Grain Growers*
Green Berry Station, Pomeroy, Washington

56, 57. *Staley, Washington*

58. *Whitman County Grain Growers elevator 95J*
Pullman, Washington (demolished 2000)

59. *Johnson Union Warehouse Company elevator*
Johnson, Washington
(partially demolished 1984)

61. *Jorstad barn*
east of Pullman, Washington

62. *Ralph Thompson barn*
north of Viola, Idaho

63. *Sharon Hanford barn*
in a field near County Road 2350,
Whitman County, Washington

64. *Richard Hall barn*
highway 23, west of Steptoe, Washington
(demolished June 1985)

65. *Duveen Kosola barn*
Jenkins Road, Whitman County, Washington
(removed)

66. *Steever barn*
northeast of Pullman, Washington (removed)

67. *Harold Kamerrer barn*
Ewartsville Road, west of Pullman,
Washington

68. *Tommy Williams barn*
off highway 23, east of St. John, Washington

69. *Robert Young barns*
Story Road, west of Pullman, Washington
(rear barn destroyed by fire)

70. *Hugh Vandemark barn*
West Cove Road, southwest of Potlatch, Idaho

71. *Elmer Blackman barn*
Malden North Road, near Malden,
Washington (demolished ca. 1981)

72. *Terry Walser barn*
Flannigan Creek Road, southwest of
Potlatch, Idaho

73. *Tom Busch barn*
Schlee Road, southwest of Colton, Washington
(removed)

74. *Eugene Brannon barn, Goose Creek Road*
Whitman County, Washington (removed)

75. *Thelma Gray barn*
Viola, Idaho (collapsed winter of 1984–85)

76. *Catherine Walker barn*
southwest of Potlatch, Idaho

77. *Craig Willson barn*
highway 195, north of Colfax, Washington

78. *Earl Mohr barn*
southwest of Colfax, Washington
(collapsed winter of 1984–85)

79. *T.A. Leonard barn*
Old Moscow Highway, east of Pullman,
Washington

80. *Carothers barn*
Carothers Road, west of Pullman, Washington

81. *Lowell Hargus barn*
Hill Road, Whitman County, Washington

82. *Matt Mengelkamp barn*
near Joel, Idaho

| | | | | |
|---|---|---|---|
| 83. | Richard McCroskey barn
Highway 195, north of Pullman, Washington
(removed) | 105. | Ripening wheat
Whitman County, Washington |
| 84. | Elsie Blane barn
northeast of Potlatch, Idaho (collapsed) | 106. | Hay bales
Whitman County, Washington |
| 85. | Leonard Beavert barn
Nez Perce County, Idaho | 107. | Stubblefield
Whitman County, Washington |
| 86. | Marvin Link barn
Whitman County, Washington | 108. | Fields in frost
north of Pullman, Washington |
| 87. | Norman Kunze barn
Diamond, Washington | 109. | Winter hillscape
north of Johnson, Washington |
| 88. | Ansie Askins barn, formerly the Skeens School
Fugate Road, Whitman County, Washington.
One of the last remaining country school
buildings in the Palouse. | 110. | Pine, fence, and fields
Latah County, Idaho |
| | | 111. | Kamiak Butte
Whitman County, Washington |
| 89. | Anderson barn, formerly Our Savior's
Lutheran Church
north of Genesee, Idaho | 112. | Pines in frost
Kamiak Butte, Whitman County, Washington |
| 91. | Cow parsnip, Kamiak Butte
Whitman County, Washington | 113. | Aspen grove
Steptoe Butte, Whitman County, Washington |
| 92. | Balsamroot and lupines
Steptoe Butte, Whitman County, Washington | 114, 115. | North slope of Kamiak Butte
Whitman County, Washington |
| 93. | Salsify
Latah County, Idaho | 116. | Apple tree
Steptoe Butte, Whitman County, Washington |
| 94. | False hellebore and a fragment of prickly lettuce
Latah County, Idaho | 117. | Steptoe Butte, Whitman County, Washington |
| 95. | Union Creek
Whitman County, Washington | 118. | Off the Goose Creek Road
Whitman County, Washington |
| 96. | Smith Road
Whitman County, Washington | 119. | Black locust grove
Whitman County, Washington |
| 97. | Abbott Road
Whitman County, Washington | 120. | New grass
Latah County, Idaho |
| 98. | Plowed field
Staley, Washington | 121. | Grass and thistles
Latah County, Idaho |
| 99. | Hillscape west of Pullman, Washington | 122. | Grassfield and Ball Butte
Latah County, Idaho |
| 100. | Landscape southwest of Potlatch, Idaho | 123. | Grass and clouds
Latah County, Idaho |
| 101. | Landscape west of Pullman, Washington | 124. | Dry grass
Whitman County, Washington |
| 102. | Wheatfield with cornflowers
Latah County, Idaho | 125. | Grass and pail
Latah County, Idaho |
| 103. | Wheatfield
Whitman County, Washington | | |
| 104. | Wheatlands
Whitman County, Washington | | |

ABOUT THE AUTHOR

Since he began documenting the landscape and architecture of the Palouse in 1969, George Bedirian's goal has been to reveal the uncommon in the commonplace—in the words of Joseph Conrad, "to make you see." He has exhibited his photography throughout Washington, in Idaho and Oregon, on the East Coast, and as far afield as the Republic of Armenia, and he has published in such magazines as *The Living Wilderness, Landscape Journal, American Land Forum, Incredible Idaho, Northwest Edition*, and *Washington Magazine*. In 1987 Bedirian assembled the best of his images in the first edition of *Palouse Country*. The book's depiction of the towns, elevators, barns, and landscapes of the Palouse has established it as a classic of regional photography.